W9-ABN-319

To the Lighthouse

The Marriage of Life and Art

TWAYNE'S MASTERWORK STUDIES
Robert Lecker, General Editor

To the
Lighthouse

The Marriage of Life and Art

Alice van Buren Kelley

TWAYNE PUBLISHERS • BOSTON
A Division of G.K. Hall & Co.

To the Lighthouse: The Marriage of Life and Art
Alice van Buren Kelley

Twayne's Masterworks Studies No. 11

Copyright 1987 by G.K. Hall & Co.
All rights reserved.
Published by Twayne Publishers
A Division of G.K. Hall & Co.
70 Lincoln Street
Boston, Massachusetts 02111

Copyediting supervised by Lewis DeSimone
Book production by Janet Zietowski

Typeset in 10/14 Sabon
by Compset, Inc.

Printed on permanent/durable acid-free paper
and bound in the United States of America

Library of Congress Cataloging in Publication Data

Kelley, Alice van Buren.
 To the lighthouse.

 (Twayne's masterwork studies ; no. 11)
 Bibliography: p.
 Includes index.
 1. Woolf, Virginia, 1882–1941. To the lighthouse.
I. Title. II. Series.
PR6045.072T676 1987 823'.912 87-14920
ISBN 0-8057-7982-5 (alk. paper)
ISBN 0-8057-8011-4 (pbk. : alk. paper)

To George, David, Rik, Ian, and Nathan,
who fed and watered this particular tree
and dug about its roots that it might
bear fruit,
and to the original
Planter of the seed,
with thanksgiving

Contents

Note on References

The following works, frequently cited in the text, will be noted by these appropriate abbreviations:

V&D Roger Fry, *Vision and Design*
CE Virginia Woolf, *Collected Essays*
MoB Virginia Woolf, *Moments of Being*, 2d ed.
ROO Virginia Woolf, *A Room of One's Own*
TtL Virginia Woolf, *To the Lighthouse*
TtLd Virginia Woolf, *To the Lighthouse: The Original Holograph Draft*, ed. Susan Dick

Full bibliographic information for each work appears in the bibliography.

The Harcourt Brace Jovanovich edition of *To the Lighthouse* has been selected for this study since it is most readily available to readers in the United States.

Chronology
Virginia Woolf's Life
and Works

1882 25 January. Birth of Adeline Virginia Stephen, third child, after Vanessa and Thoby, of the marriage of Leslie Stephen, eminent Victorian man of letters, and Julia Princep Duckworth, both of whom had been married before and brought children with them into this second marriage—Laura Stephen, who was retarded, and three Duckworth offspring, George, Gerald, and Stella. All live at 22 Hyde Park Gate, Kensington, depicted in *The Years*, and spend summers at Talland House, St. Ives, the setting for *To the Lighthouse*.

1883 Birth of Adrian Leslie Stephen, last of Virginia's siblings.

1895 Death of Julia Stephen. Soon after the death of her mother, Virginia experiences her first breakdown. The Stephens' household is steeped in formal mourning, the lease of Talland House sold.

1896 Vanessa, Virginia's older sister, begins art classes, and Stella Duckworth, who had taken over the running of the Stephens' household at the death of her mother, becomes engaged.

1897 Virginia experiments with a diary and is considered strong enough to return to her lessons for a time, though periods of illness continue. Stella marries and moves down the street but continues to be very involved with her half-brothers and -sisters until her sudden death from peritonitis in July. Vanessa takes over the running of the house, putting up with her father's tempers and melodramatic displays of grief.

1899 Thoby Stephen, Virginia's older brother, enters Trinity College, Cambridge, where he becomes friends with Clive Bell, Lytton

Strachey, Leonard Woolf, and others who later figure in the now legendary "Bloomsbury Group."

1900 George Duckworth attempts to introduce Virginia into proper Edwardian society. She is shy, awkward, and miserable, being prone to shock her elegant hostesses by suddenly quoting volubly from the classics, which she has been reading under her father's informal tutelage.

1902 Virginia begins private lessons in Greek with a tutor, Janet Case. Leslie Stephen knighted.

1904 Death of Sir Leslie Stephen on 22 February. Some months later Virginia experiences her second breakdown, complicated by scarlet fever. George Duckworth marries Lady Margaret Herbert and the Stephens move to 46 Gordon Square, Bloomsbury, a part of London seen as beyond the pale of polite society. Here they shake off the daily pattern of Victorian living and begin to define a new, freer style of life. Virginia's first publication, an unsigned review in the *Guardian*.

1905 Virginia pronounced "cured" by her doctor. Thoby Stephen initiates "Thursday Evenings" to which his Cambridge friends come to talk, or to sit meditatively puffing on their pipes. These evenings begin Virginia's active engagement with the sort of abstract give-and-take common to the Apostles, a famous Cambridge intellectual society to which many of Thoby's friends belonged. Virginia begins volunteer teaching at Morley College for working men and women.

1906 The Stephens travel to Greece. There Vanessa is taken ill with typhoid fever and, on their return, Thoby dies of the same disease.

1907 Vanessa marries Clive Bell, and Virginia and Adrian move to 29 Fitzroy Square, where Virginia begins work on a novel (*Melymbrosia*) that later becomes *The Voyage Out*.

1908 Birth of Julian Heward Bell, Vanessa's first child.

1909 Lytton Strachey proposes to Virginia and is accepted. The "engagement" is broken by mutual consent the next day. Virginia meets Lady Ottoline Morrell, eccentric patroness of many important writers and artists of the period; the beginning of a long acquaintance.

1910 Virginia begins volunteer work for women's suffrage. She also takes part in "The Dreadnought Hoax," in which she and a group of her male friends tricked the British navy into giving a tour of a top secret man-of-war to the "Emperor of Abyssi-

nia" and his retainers, of whom she, with browned face, false mustache, and a supply of scrambled Latin, was one. November–January 1911, First Post-Impressionist Exhibition, (featuring the work of Cézanne) organized by Roger Fry, who later becomes Vanessa's lover and a prominent presence in Bloomsbury with his theories on art that focused on the formal rather than the representational aspect of painting.

1911 Virginia and Adrian move to 38 Brunswick Square, which they share with Maynard Keynes, Duncan Grant, and Leonard Woolf, lately returned from administrative duties in Ceylon.

1912 Virginia sets up a country retreat at Asham House, Beddingham, but soon must enter a nursing home at Twickenham for a short rest cure. In May she accepts the proposal of Leonard Woolf after much deliberation. Marriage of Virginia Stephen and Leonard Woolf, 10 August, at a London registry office. On return from honeymoon, Leonard works as secretary to Second Post-Impressionist Exhibition.

1913 *The Voyage Out* accepted for publication. Virginia grows increasingly depressed and attempts suicide. Ill for many months.

1914 4 August, World War I begins for Great Britain. The Woolfs move to Richmond.

1915 Virginia resumes long-neglected diary. Woolfs move to Hogarth House, where they plan to set up a printing press. *The Voyage Out* published. Virginia's most serious mental breakdown, including several months of raving madness followed by very gradual recovery. Return to normal by mid-November.

1917 Hogarth Press begins publication with "The Mark on the Wall," Virginia's first piece of experimental fiction, and Leonard's "Three Jews," both hand-set by the authors. Virginia begins work on *Night and Day,* her most traditional novel.

1918 Virginia writes frequently for the *Times Literary Supplement.* Lytton Strachey publishes *Eminent Victorians.* Virginia becomes friends with T. S. Eliot. 11 November, Armistice Day; the war ends.

1919 Hogarth Press publishes Virginia's "Kew Gardens" and T. S. Eliot's *Poems.* The Woolfs buy Monk's House, Rodmell, which remains their country house until they die. *Night and Day* published.

1920 Leonard involved in politics. Virginia works on *Jacob's Room,* her first experimental novel.

1921	Publication of *Monday or Tuesday*, a collection of Virginia's stories.
1922	*Jacob's Room* published.
1923	Virginia begins work on *The Common Reader* and *Mrs. Dalloway*, first called "The Hours."
1924	Publication of "Mr. Bennett and Mrs. Brown," outlining her theory of successful (and unsuccessful) creation of fictional characters. Friendship with Vita Sackville-West begins.
1925	Publication of *Mrs. Dalloway* and *The Common Reader*.
1926	*To the Lighthouse* begun.
1927	*To the Lighthouse* published and reviewed as a masterpiece. *Orlando*, a fantastical biography of Vita Sackville-West, begun.
1928	*Orlando* published. A financial and critical success. Virginia lectures to the women's colleges at Cambridge on the topic "A Room of One's Own."
1931	Publication of *The Waves*, begun in 1930. Begins work on *Flush*.
1932	Death of Lytton Strachey. Publication of *The Common Reader: Second Series*. Begins work on *The Years*, first called "The Pargiters."
1933	Publication of *Flush*, story of Elizabeth Barrett Browning's dog.
1934	Death of Roger Fry.
1936	Virginia begins *Three Guineas*.
1937	Work on the biography of Roger Fry and publication of *The Years*, a book that causes Virginia great suffering to complete, and with which she is never satisfied, though it sells well. Death of Julian Bell in the Spanish Civil War.
1938	Hitler invades Austria.
1939	Death of Leonard's mother. England declares war.
1940	Hitler invades Norway and Denmark. Italy enters the war. Virginia and Leonard make plans for suicide should Hitler invade England. Their home in London bombed.
1941	*Between the Acts* completed. Virginia, sensing madness returning, writes a loving note to Leonard, puts heavy stones in her pockets, walks into the River Ouse, and drowns herself.

— 1 ————————

HISTORICAL CONTEXT

"On or about December, 1910," said Virginia Woolf in a lecture to a group of Cambridge undergraduates, "human character changed"; and a sense of change, rapid or even precipitous, dominated the age in which she lived and wrote. When she was born, Queen Victoria was on the throne; and during the years of her childhood and adolescence, the then Miss Stephen lived as a proper Victorian. Privileged young ladies of her day (who, of course, could not vote, should not smoke, could not be subjected to the brutality of a word as harsh as *damn*, and would not be expected to choose any profession other than marriage) presided over tea in the afternoons, exchanging the sugary insincerities of polite conversation with their teacups and tea cakes, and then dressed in formal evening clothes, even at home, for dinner. They took the carriage out for visits, wrote letters by the dozens, and prepared themselves to run their households as their mothers before them. When Virginia Woolf finally took her own life, in March 1941, that Victorian world was gone. Gaslight had given way to electricity, horses and carriages to automobiles and airplanes, flowing skirts and waist-length hair to the practical styles of modern day. Women caught buses to their jobs in factories or offices where inventions like the

telephone and the typewriter quickened the pace of life. Workers joined unions and organized nationwide strikes. Industry burgeoned, and, practically overnight, the tranquil meadows beyond the windows of Woolf's country house were blighted by a great cement factory.

The major event that opened a wide crevasse in the early years of the twentieth century, just after Woolf's announced alteration in human character, was World War I. This war, which was carried forward initially by waves of eager volunteers who were ready to fight for the traditions of the past and to achieve victory in a few glorious months, soon settled into a great bog of lost lives and lost innocence. Young men who began by seeing war as a game, even carrying out attacks while kicking soccer balls across no-man's-land with the German line as goal, were killed by the hundreds of thousands in ill-planned assaults or wore out their days in the fetid, waterlogged, rat-infested trenches. Just as the war arena changed from a pastoral landscape to a wasteland of shattered trees and puddled shell holes, so the notion of a predictable world, tied securely to a familiar past, began to give way to a sense of larger uncertainty, of radical change. Although men did return from the war, they left half a generation of their brothers lying dead behind them and came home to a world permanently colored by the horror they had seen and a sense that things would never be the same.

They were right. War had increased the speed of industrial and social change. It had brought women into factories and businesses to take the place of the men who had died or were in battle, and so helped to gain women the vote. It forced people to confront the fragility of life and opened the way for an expectation of the new, the unpredictable. Even poetry, which sprang up in poppies and measured Georgian lyrics at the outset of the war, emerged from battle full of fragmented lines, broken rhythms, and stark, cryptic images.

Of course the war was not the cause of all this change. The suffrage movement was well under way before the first bombs fell. The industrial revolution was undeniable in Dickens's day. And art had begun to free itself from the limits imposed on it by tradition well before Rupert Brooke was succeeded by T. S. Eliot. But the war ac-

celerated the rate of change and created a climate for experiment.

In art, particularly, the old values and techniques were coming under criticism, and Virginia Woolf may have chosen her date of change, December 1910, from the fact that the First Post-Impressionist Exhibition was receiving most attention then. Roger Fry, who organized this exhibition and who was a lifelong friend of Woolf's, wrote a number of influential articles at this time, denigrating the representational aspect of art and stressing the communicative power of form over content, while painters of his day reflected this same movement from realism toward the abstract. Cézanne, Rouault, Braque, Picasso, and Duchamp were among those gaining attention; and although people who came to see their work often reacted with laughter or with shock, the old academy paintings were rapidly falling out of favor. In music, Stravinsky, Debussy, Schönberg, and Bartók, in different countries and with different techniques, were shaking audiences in their seats and asking human ears to hear music where they had never heard it before. And in literature, during the years when Woolf was at her peak, there appeared a number of works—among them Joyce's *Ulysses,* Eliot's *The Waste Land,* and Conrad's *Heart of Darkness*—that became the standard measure of what is still called literary modernism. By drawing readers into dizzying worlds of many-voiced narrative, shifting time, and elusive allusion, these works challenged both traditional notions of plot, chronology, and character, as well as common, comfortable attitudes toward the self and society.

Many of the changing attitudes in art reflected changes in the larger intellectual life of the time. The works of Karl Marx were refocusing opinions about the structure of society and the influences shaping the social and economic relationships among human beings; and the writings of Freud were revealing the complexity and elusiveness of personality, declaring that men and women are as many-layered as an onion and suggesting the existence of a discomforting class system within the human psyche. If a person could express through dreaming, in all its disjunctive, bizarre, and occasionally frightening movement, a deeper, hidden, and perhaps more truthful self than what was presented to the world in the light of day, then the way to offer

the truth in general suddenly became more complicated. People began to understand themselves and each other differently, and artists and writers frequently gave body to this new conception of the human animal, political or personal, through techniques equally complex— stream-of-consciousness, private symbol, or seemingly fragmented form.

Much of Woolf's critical writing draws attention to the sense of uncertainty that both threatened and enlivened the world in which she lived. In 1927, the same year that *To the Lighthouse* was published, Virginia Woolf wrote for the *New York Herald Tribune* an essay entitled "The Narrow Bridge of Art." In it she describes the problems facing the modern poet, and, by extension, any artist attempting to convey a vision in her day:

> But for our generation and the generation that is coming the lyric cry of ecstasy or despair, which is so intense, so personal, and so limited, is not enough. The mind is full of monstrous, hybrid, unmanageable emotions. That the age of the earth is 3,000,000,000 years; that human life lasts but a second; that the capacity of the human mind is nevertheless boundless; that life is infinitely beautiful yet repulsive; that one's fellow creatures are adorable but disgusting; that science and religion have between them destroyed belief; that all bonds of union seem broken, yet some control must exist—it is in this atmosphere of doubt and conflict that writers have now to create, and the fine fabric of a lyric is no more fitted to contain this point of view than a rose leaf to envelop the rugged immensity of a rock. (CE 2:218–19)

From the turn of the century to the opening years of the Second World War, life was made up of a powerful new wine; and the old bottles of civilization, of philosophy, of religion, of art could not contain it. It was a tumultuous, troubling, and challenging time.

– 2

THE IMPORTANCE OF THE WORK

To the Lighthouse is generally considered Virginia Woolf's greatest work. It has won awards, received copious critical attention (including several books devoted to it alone), and has served as one of the main examples of what is currently called modernist fiction, being set next to the novels of Joyce and Conrad, and occasionally Lawrence and Forster, in countless undergraduate and graduate courses in English departments around the world. When Woolf wrote *To the Lighthouse,* she had worked her way through "The Mark on the Wall," *Jacob's Room,* and *Mrs. Dalloway,* and had gained full control of her experimental techniques. In fact she composed it with a joy and a fluidity that she encountered only intermittently in the creation of her other fiction. Reading through the original holograph draft, in which many of the most effective and subtlest passages appear in a form nearly identical to that of the final version, one can see the speed with which she wrote and appreciate how sure a structure was in her mind from the outset of her writing. A scene may be reshaped, a character's thoughts expanded or curtailed, the narrative stance shifted a degree or two, but the draft as a whole shows few signs of the painful labor that several of her other novels cost her. As published, the completed

novel is full of delicate refinements on the original shape, not major reworkings.

The novel as we read it is a meticulously crafted whole. In it are gathered an elaborate assembly of themes, as diverse yet harmoniously arranged as the seashells and fruit that stand as centerpiece on the Ramsays' dinner table. Giving it emotional vividness, authenticity, and a genuine sense of intimacy are the models behind the Ramsays, Virginia Woolf's own parents, who walked like powerful ghosts through her life until she exorcised them here. But *To the Lighthouse* is fiction, not pure biography, and the Ramsays and their household go beyond the personal to offer an intelligent setting forth of the conflict between the Victorian and the modern worlds, particularly on the question of the proper role for women. In developing this theme, "The Window" represents the past, "The Lighthouse" Woolf's present, and between them the shattering years of the First World War, contained in "Time Passes."

Yet social issues are only a part of *To the Lighthouse,* for Woolf was more interested in human nature in general than in any particular historical definition of men and women. Using techniques that broke from the old ways of presenting character as surely as the war shattered other traditions of the past, she set about presenting personality through methods best described by Lily Briscoe as she attempts to capture the fullness of Mrs. Ramsay: "One wanted most some secret sense, fine as air, with which to steal through keyholes and surround her where she sat knitting, talking, sitting silent in the window alone; which took to itself and treasured up like the air which held the smoke of the steamer, her thoughts, her imaginations, her desires. What did the hedge mean to her, what did the garden mean to her, what did it mean to her when a wave broke?" (TtL 294). In exploring her characters with a touch that goes into the depths but moves there as lightly as a small sea breeze, Woolf takes risks and challenges her reader to venture beyond conventional expectations and in so doing has caused many to look at themselves and those around them in new ways.

But for all its moving portrayal of Woolf's own past, its exploration of the tension between two social worlds, its sensitive uncov-

ering of the human spirit, what is perhaps most satisfying about *To the Lighthouse* is Woolf's achievement as an artist. Like Lily Briscoe with her paints and brushes, balancing the dark on the right with the light on the left, Woolf carefully sets scene against scene, thought against thought, and so addresses, as she perceives it, the question that rises in the minds of her characters whenever the rush of the world subsides and leaves them room for contemplation: what is the meaning of life? Is there a pattern beneath the flux? a hope for reconciliation in a world of countless oppositions? With a combination of love for her subject and a scrupulous honesty, Woolf so arranges the fruit of her observations that the reader, who has been lured into a complex, occasionally confusing, inner and outer landscape, emerges at the end with a sense of wholeness and satisfaction. Fullness and emptiness, imagination and reason, present and past, female and male, pleasure and pain, all have been so finely balanced that the novel embodies the marriage of chaos and order that Woolf saw making up the larger work of art that lay before her in life itself.

— 3

CRITICAL RECEPTION

When serious reviewers, seeking comparisons to describe the work of a contemporary novelist, begin to invoke the names of the traditional literary titans, that is a good sign of approaching fame; and by the time *To the Lighthouse* was published in 1927, Virginia Woolf was not infrequently being set in the company of seminal writers like Jane Austen and Laurence Sterne. But the calling up of these particular literary predecessors indicated something more than the growing respect that the critics had for Woolf's fiction. It also suggested that her work was stretching and challenging the intellectual capacities of her readers. Austen and Sterne approach the novel so differently that any fictional offspring of theirs would necessarily combine the decorous with the daring, the mannerly with the mad, the world of external social relationships with that of internal emotions and obsessions; and it is this very multiplicity that puzzled, even as it impressed, Woolf's reviewers. An unsigned review in the *Times Literary Supplement* on 5 May 1927, for example, declared: "A case like Mrs. Woolf's makes one feel the difficulty of getting a common measure to estimate fiction; for her work, so adventurous and intellectually imaginative, really invites a higher test than is applied to most novels."[1]

Although the structure of *To the Lighthouse* and its composition seem to have come more quickly to Woolf than those of her other novels, even from the outset it was clear that she was attempting to combine in it many of the concerns that dominated her life and her fiction. In May 1925, when the novel was just taking shape in her mind, she wrote in her diary: "This is going to be fairly short: to have father's character done complete in it; & mother's; & St Ives; & childhood; & all the usual things I try to put in—life, death &c."[2] In July of that same year, still before the actual writing was under way, she was already at work adding layers to her original idea: "I think, though," she wrote,

> that when I begin it I shall enrich it in all sorts of ways; thicken it; give it branches & roots which I do not perceive now. It might contain all characters boiled down; & childhood; & then this impersonal thing, which I'm dared to do by my friends, the flight of time, & the consequent break of unity in my design. That passage (I conceive the book in 3 parts: 1. at the drawing room window; 2. seven years passed; 3. the voyage) interests me very much. A new problem like that breaks fresh ground in one's mind; prevents the regular ruts.[3]

Small wonder, then, that Woolf's early critics found much to bemuse as well as to amaze them: large themes—life, death, childhood, time; new methods of characterization—the "boiling down" of characters; and fresh experiments in style and form that led Woolf herself to wonder whether one might need "a new name for [her] books to supplant 'novel.'" If *To the Lighthouse* broke fresh ground in her mind, it did the same for her readers.

In March 1928 *To the Lighthouse* won the French *Prix Femina*, a sign of Virginia Woolf's growing international reputation. But for all her acclaim, readers still did not find her novels easy to understand. As reviewers gave way to more formal critics and short newspaper assessments to long journal articles or even books, discussion of her central works of fiction reflected the fact that those exploring the worlds she had created often found them foreign and not always

hospitable. Some early critics, notably those writing for *Scrutiny*, for example, put off by her unusual approach to plot and characterization (and, it must be admitted, sometimes reacting as much to her association with the intellectual aristocracy of Bloomsbury as to her work itself) accused her of elitism and faulted her for avoiding themes that would lead to social change. Such criticism often came from those whose own work was addressing contemporary political issues with passion, for social action was the primary concern of many critics and writers in the generation just following Woolf's. This shift in critical focus was the first of many reactions to her fiction that depended less on the intrinsic subject of her work than on a general change in intellectual climate.

Some aspects of *To the Lighthouse* have gained appropriate attention no matter what the preoccupations of the critic. Woolf's particular perception of reality and her attempt to let her style and form, the rhythm of her novels, reflect this perception have been discussed sensitively by a number of critics from the first, notable among them Joan Bennett, Bernard Blackstone, and David Daiches. Other writers have noticed her emphasis on the dichotomous elements of life (male/female, intellectual/emotional, social/psychological, for example); her complex treatment of time, an element carefully studied by James Haffley, Harvena Richter, and Margaret Church, among others; her interest in feminist issues; her absorption of philosophical or aesthetic ideas to which she had been seriously exposed, a phenomenon first examined by J. K. Johnstone; and her careful use of her own past in her creation of a fictional present. But some of these issues awaited the arrival of new information or an upsurge in popular interest to gain extensive treatment while other elements, equally intriguing, have yet to be explored in any depth.

Perhaps the two aspects of *To the Lighthouse* (and of Woolf's work in general) that have set off the most sustained critical excitement in recent years are its presentation of feminist themes and its relationship to Woolf herself. The two aspects are not unrelated, for the feminist perspective has been fed by a new understanding of her life. Ever since 1928, when Virginia Woolf delivered the lecture that

was to be published as *A Room of One's Own,* no one could mistake her concern with the role of women in her society and the restrictions, especially artistic restrictions, placed upon them by a masculine tradition. Herbert Marder made this theme in Woolf's fiction the focus of his study in the late 1960s, but it was not until the relatively recent publication of a number of biographical and autobiographical materials that this concern could be seen in context. The result has been the burgeoning of interest in the autobiographical nature of her work, especially *To the Lighthouse.*

In 1972 Quentin Bell published a two-volume biography of his famous aunt. In the eight years that followed there appeared the five volumes of her diaries and the six volumes of her letters as well as the important *Moments of Being: Unpublished Autobiographical Writings.* Bell's own biography dealt very little with the fiction; but, more recently, several literary biographies, one of the best being Phyllis Rose's *Woman of Letters,* have built on his work, in an attempt to extend our understanding of Woolf by explaining the relationship between her experience and her art. A number of critical studies, too, have examined the novels in the light of Woolf's upbringing, marriage, and daily interchange with her friends and family. Considering the modern fascination with the workings of the unconscious, it is not surprising that some critics have found in the biographical information the means to undertake a frankly psychoanalytic approach to her fiction, focusing particularly on its treatment of death or sexuality. But others have returned to her feminist vision and have traced it to her personal past. Since *To the Lighthouse* is Woolf's most self-confessedly autobiographical work, offering portraits of her parents and, parenthetically (in a quite literal sense), a number of the tragedies that struck her own youth like physical shocks, it makes sense to search there for her self-portrait as a female artist, her view of herself in relation to a much admired Victorian mother who served as a sort of icon for a particular vision of the feminine, and her perception of the change in women's lives brought about by the emergence of the new postwar world. Two interesting studies in this line are Jean O. Love's *Virginia Woolf: Sources of Madness and Art* and Maria DiBattista's

recent *Virginia Woolf's Major Novels: The Fables of Anon*. Feminist
critics have also examined the implications of Woolf's choice of form,
imagery, and the like for her concern with women's issues, interweav-
ing her life and her art in a particular thematic pattern, a critical trend
well represented by the volume edited by Jane Marcus, entitled *Vir-
ginia Woolf: A Feminist Slant*.

But contemporary criticism is by no means restricted to feminist
and biographical approaches and is even undercutting established
views of her work. Whereas, for example, early studies tended to mark
Woolf as the quintessential modernist, more recent books, like Perry
Meisel's *The Absent Father: Virginia Woolf and Walter Pater*, have
begun to trace her roots in the Victorian past, and her use of allusion,
to suggest a literary continuity between earlier periods of fiction, or
even of poetry, and the seemingly unsettled world of the twentieth
century that she describes. Other critics, notably Allen McLaurin and
Thomas Matro, have examined her relationship to the nonliterary art
of her period, discussing the influence of Roger Fry on her fictional
form. Still others have chosen some focused thematic issue such as the
concept of the self and have examined it with thoroughness. In fact,
as Virginia Woolf becomes more and more firmly established as one
of the primary writers of fiction in the twentieth century, critics have
had the leisure to walk all the way around her, so to speak, and pick
out the view of her work they find most exciting, regardless of whether
it fits the current trends. Lily Briscoe, painting the house and the lawn
and the shadow of Mrs. Ramsay in *To the Lighthouse*, refuses to con-
form to the popular formula for painterly realism. She won't paint the
jacmanna a gentle, pastel lavender if she sees it as staring purple, for
she insists on painting what she sees. In recent years the critics of *To
the Lighthouse* have been just as independent in their views, and al-
though one revelation may well inspire a small rush of related finds,
the possibilities for variety seem endless. Several entire books have
been devoted to this one novel without exhausting all that there is to
say about it. So a reader today, coming fresh to this novel or arriving
well-armed with the dissecting tools forged by critics past, is bound to
find in *To the Lighthouse* "so adventurous and intellectually imagi-

native" a work that it will still, as it did for Woolf's first reviewers, invite "a higher test than is applied to most novels," and will lead to discoveries that no critic yet has made. Woolf would be delighted, for she was well aware of the need to examine any subject from many angles in order to discover the truth about it. "One wanted fifty pairs of eyes to see with, she reflected. Fifty pairs of eyes were not enough to get round that one woman with, she thought" (TtL 294). So Lily approaches Mrs. Ramsay, and so Woolf would wish her readers to approach her novel.

— 4

THE PROBLEMS
SET FORTH

In 1919, after the First World War had dropped like a heavy stone through what was left of the civilized web of Victorian convention, Virginia Woolf wrote an essay called "Modern Fiction" in which she looked about her to see how writers were faring amid the turmoil of her day. What she found did not satisfy her. "Admitting the vagueness which afflicts all criticism of novels," she wrote, "let us hazard the opinion that for us at this moment the form of fiction most in vogue more often misses than secures the thing we seek. Whether we call it life or spirit, truth or reality, this, the essential thing, has moved off, or on, and refuses to be contained any longer in such ill-fitting vestments as we provide" (CE 2:105). Two issues trouble her here—the content of the novel and the form that contains it—and both the pursuit of life, or reality, or "the essential thing," and the net in which to catch it were to challenge her throughout her career as a writer.

When faced with a contemporary problem, one sensible course of action is to turn back to those who have succeeded in overcoming similar obstacles, and Virginia Woolf, who was more widely read than many a modern scholar, was intimately acquainted with her literary forerunners and was quick to consult them in solving the dilemma of the twentieth-century novelist. One of the sources of dissatisfaction

that Woolf felt when reading the work of those whose fiction was "in vogue" in 1919 was that these writers, Arnold Bennett, H. G. Wells, and John Galsworthy among them, focused their attention on the material world in order to lead the reader, as Woolf put it, to join a society or to write a check. Their novels seemed unfinished until the reader gave them an ending in the life of action. But the novels of writers like Sterne or Austen had managed to avoid this lack of internal integrity. "*Tristram Shandy* or *Pride and Prejudice* is complete in itself," Woolf wrote in "Mr. Bennett and Mrs. Brown"; "it leaves one with no desire to do anything, except indeed to read the book again, and to understand it better" (CE 1:327).

Did the eighteenth- and early nineteenth-century writers, then, have the answer to the modern question of how to write a novel? It was tempting to say yes, but the solutions they provided for Woolf were not quite the ones she sought. Their work was balanced, whole, harmonious, and yet, and yet. . . . Here is the way Woolf voiced her ambivalence in "How It Strikes a Contemporary":

> There is an unabashed tranquillity in page after page of Wordsworth and Scott and Miss Austen which is sedative to the verge of somnolence. Opportunities occur and they neglect them. Shades and subtleties accumulate and they ignore them. They seem deliberately to refuse to gratify those senses which are stimulated so briskly by the moderns [and here she is referring to writers like Conrad and Joyce, who had chosen another route from that taken by Bennett and his kin]; the sense of sight, of sound, of touch—above all, the sense of the human being, his depth and the variety of his perceptions, his complexity, his confusion, his self, in short. There is little of all this in the works of Wordsworth and Scott and Jane Austen. From what, then, arises that sense of security which gradually, delightfully, and completely overcomes us? It is the power of their belief—their conviction, that imposes itself upon us . . . conviction that life is of a certain quality. They have their judgment of conduct. They know the relations of human beings towards each other and towards the universe (CE 2:158–59).

And, she adds, "certainty of that kind is the condition which makes it possible to write. To believe that your impressions hold good for

others is to be released from the cramp and confinement of personality."

To write, one needs the conviction that one's readers will accept what one offers as true. In fact Woolf defines integrity, for the novelist, as this ability to translate one's beliefs directly to the reader and asserts that Sterne and Scott and Austen had this integrity. They knew what human beings were and how they related to one another and to the universe, and their conviction carried over to their readers. Yet for all their certainty about human nature and the sense of security it provides, Woolf finds in their works very little of what *she* understands the human being to be. So these writers had an answer, an answer that worked for them and is a delight even to the modern reader. Yet the methods they used could not be taken over wholesale by the would-be novelist in the twentieth century, for something was missing.

In *A Room of One's Own,* after praising the achievement of Jane Austen, the one early writer, besides Shakespeare, to whom Woolf returns again and again as a model, Woolf poses a question to the modern, female writer, asking, "But why . . . are Jane Austen's sentences not the right shape for you?" (ROO 84). And the answers she finds are complex. In the first place, contemporary writers do not stand on the same ground that Austen occupied so comfortably, because, for one thing, "they have ceased to believe. . . . They cannot tell stories because they do not believe that stories are true" (CE 2:159). So that integrity, that conviction, necessary to a writer, is hard to come by for the woman, or the man, who picks up a pen to write a novel in Woolf's day. What has so undermined a solid sense of truth as to make the modern writer step out into fiction as onto a thin crust of snow that may break any moment underfoot and leave him or her floundering? With a touch of effective exaggeration, Woolf explains: "on or about December 1910, human character changed. . . . All human relations have shifted—those between masters and servants, husbands and wives, parents and children. And when human relations change there is at the same time a change in religion, conduct, politics, and literature" (CE 1:320–21). So Austen's way will not do for the modern writer who does not share her conviction about human nature because human nature itself has changed.

In "How It Strikes a Contemporary" Woolf makes our separation from the past and the cause of that separation very clear: "We are sharply cut off from our predecessors," she says; "A shift in the scale—the sudden slip of masses held in position for ages—has shaken the fabric from top to bottom, alienated us from the past and made us perhaps too vividly conscious of the present. Every day we find ourselves doing, saying, or thinking things that would have been impossible to our fathers." In the face of such changes, she goes on to say, it is to books that we turn, "in the hope that they will reflect this rearrangement of our attitude—these scenes, thoughts, and apparently fortuitous groupings of incongruous things which impinge upon us with so keen a sense of novelty—and, as literature does, give it back into our keeping, whole and comprehended" (CE 2:157–58). Like Austen, the modern writer must attempt to comprehend and present whole the truth that he or she sees, but when the truth to be comprehended is a new truth, the form in which it is presented must be a new form, and Woolf saw around her, "on all sides writers . . . attempting what they cannot achieve, . . . forcing the form they use to contain a meaning which is strange to it" (CE 2:218). Part of the difficulty arose from the fact that modern readers felt the new world around them too strange to be taken straight: "In the vast catastrophe of the European war," Woolf writes, "our emotions had to be broken up for us, and put at an angle from us, before we could allow ourselves to feel them in poetry or fiction" (CE 1:10). But the greater part of the problem stemmed from the complexity of the truth, the emotions it evoked, and the need to discover a form strong enough to hold so much confusion and give it shape.

What is this truth that seemed to have eluded Woolf's literary ancestors? And how ought a writer to set it forth to convince the reader of its validity? In a famous passage from "Modern Fiction," Woolf describes life as the modern man or woman experiences it:

> Examine for a moment an ordinary mind on an ordinary day. The mind receives a myriad impressions—trivial, fantastic, evanescent, or engraved with the sharpness of steel. From all sides they come, an incessant shower of innumerable atoms; and as they fall, as they

shape themselves into the life of Monday or Tuesday, the accent falls differently from of old; the moment of importance came not here but there; so that, if a writer were a free man and not a slave, if he could write what he chose, not what he must, if he could base his work upon his own feeling and not upon convention, there would be no plot, no comedy, no tragedy, no love interest or catastrophe in the accepted style, and perhaps not a single button sewn on as the Bond Street tailors would have it. Life is not a series of gig-lamps symmetrically arranged; life is a luminous halo, a semi-transparent envelope surrounding us from the beginning of consciousness to the end. Is it not the task of the novelist to convey this varying, this unknown and uncircumscribed spirit, whatever aberration or complexity it may display, with as little mixture of the alien and external as possible? (CE 2:106)

As Woolf prepared to weave a net to envelop this luminous reality and give it form, she was faced personally with two particular challenges as an artist that are implied in her asking her imaginary female novelist why Jane Austen's sentences would not suit her. In the first place, Woolf was living in the thick of new and controversial theories about art in general, focused primarily on the visual arts (since those propounding the theories were painters) but not neglecting the art of literature. Clive Bell, Woolf's brother-in-law, and Roger Fry, the man who replaced him for a time as her sister Vanessa's lover, both had much to say that threatened the traditional views of art without providing any clear path for the novelist to follow. In her biography of Fry, Woolf summarizes the call, and the predicament: "He found glaring examples in Shakespeare, in Shelley, of the writer's vice of distorting reality, of importing impure associations, of contaminating the stream with adjectives and metaphors. Literature was suffering from a plethora of old clothes. Cézanne and Picasso had shown the way; writers should fling representation to the winds and follow suit. But he never found time to work out his theory of the influence of Post-Impressionism upon literature."[4] So writers must be as bold as Cézanne in creating new forms (unspecified by Fry) to contain the truth they wish to convey. If the writer is a woman, this need for a new form extends beyond the experiments of Picasso, since a woman, simply by

virtue of her sex, is faced with a particular need to find a form suited to her own, peculiar, creative vision. In "Women and Fiction" Woolf describes this challenge:

> But it is still true that before a woman can write exactly as she wishes to write, she has many difficulties to face. To begin with, there is the technical difficulty—so simple, apparently; in reality, so baffling—that the very form of the sentence does not fit her. It is a sentence made by men; it is too loose, too heavy, too pompous for a woman's use. Yet in a novel, which covers so wide a stretch of ground, an ordinary and usual type of sentence has to be found to carry the reader on easily and naturally from one end of the book to the other. And this a woman must make for herself, altering and adapting the current sentence until she writes one that takes the natural shape of her thought without crushing or distorting it. (CE 2:145)

So, as Woolf sees it, the modern writer is faced with a world that has changed so radically that the old forms cannot describe it. The need to find new forms, perhaps following the example of innovators in the visual arts, is clear if one is to give shape to the chaos that the modern world embodies, if one is to offer it to the reader whole and comprehended. For the woman who wishes to attempt this exercise in unifying and interpreting reality, the task is doubly difficult since she cannot assume that the solutions found by her male contemporaries, let alone her predecessors of either sex, will do for her.

Before setting to work to find this form and tame the flood of reality, however, the modern novelist must take a look at the aims of the genre. For Woolf, "all novels . . . deal with character, and . . . it is to express character—not to preach doctrines, sing songs, or celebrate the glories of the British Empire, that the form of the novels, so clumsy, verbose, and undramatic, so rich, elastic, and alive, has been evolved" (CE 1:324). Character is not defined primarily by what we do for a living, or even by our personal relations, for much of our life is made up of our emotions, called up by beauty, by dreams, by what we read, by thoughts of life and death and fate, experienced when we are alone

(CE 2:225). If emotions, if thinking, is the foundation of character, how hard it will be for novelists to succeed in their work, for, according to Woolf, "when it comes to saying, even to someone opposite, what we think, then how little we are able to convey! The phantom is through the mind and out of the window before we can lay salt on its tail, or slowly sinking and returning to the profound darkness which it has lit up momentarily with a wandering light" (CE 3:19). How to find a language to convey character, in the new, complex form it takes in the twentieth century? The trick, says Woolf, is to discover the rhythm behind what one wishes to say. "Once you get that, you can't use the wrong words." But, she goes on to say, in a letter to Vita Sackville-West written while she was giving birth to *To the Lighthouse*, finding that rhythm is no easy matter: "Here I am sitting after half the morning, crammed with ideas, and visions, and so on, and can't dislodge them, for lack of the right rhythm."[5] And, alas, there is one further problem in setting down character, the chief task of the novelist. For, as Woolf says, "beyond the difficulty of communicating oneself, there is the supreme difficulty of being oneself. This soul, or life within us, by no means agrees with the life outside us" (CE 3:19).

To the Lighthouse, directly and indirectly, sets down all these problems, which Woolf saw converging on the modern writer: the great, recent changes in the world, the task of discovering a form of art to give meaning to those changes, the special difficulties for a woman in discovering that form, and, for the novelist in particular, the elusiveness of that human character that forms the underlying subject of all novels. Lily Briscoe, the artist in *To the Lighthouse*, underscores this last and central problem: "How then, she had asked herself, did one know one thing or another thing about people, sealed as they were?" (TtL 79). The question echoes in her mind, and the minds of others, throughout the novel, as when Mrs. Ramsay muses on the fact that "our apparitions, the things you know us by, are simply childish. Beneath it is all dark, it is all spreading, it is unfathomably deep; but now and again we rise to the surface and that is what you see us by" (TtL 96). The danger, the delight, the frustration, and the possibility of vision available to the artist in tackling this problem are summed up by Lily, as she thinks of Mr. Ramsay and Mr. Bankes, in words

that seem to belong in the mind of a novelist: "How then did it work out, all this? How did one judge people, think of them? . . . Standing now, apparently transfixed, by the pear tree, impressions poured in upon her of those two men, and to follow her thought was like following a voice which speaks too quickly to be taken down by one's pencil, and the voice was her own voice saying without prompting undeniable, everlasting, contradictory things, so that even the fissures and humps on the bark of the pear tree were irrevocably fixed there for eternity" (TtL 40).

The artist's task is to conquer the paradox, to find the eternal in the reconciliation of the everlastingly contradictory, to capture in words sensations that move faster than words. Part of the problem lies in the fact that it is not merely the artist's subject who contains contradictions, but also the artist herself, as we see in Mrs. Ramsay's reactions to Charles Tansley: "Yet he looked so desolate; yet she would feel relieved when he went; yet she would see that he was better treated tomorrow; yet he was admirable with her husband; yet his manners certainly wanted improving; yet she liked his laugh" (TtL 174). Within a breath, one's reaction to another can shift from love to indifference, pity to irritation, distaste to affection. So to know someone, and to present that someone, through art, to another, is no task for the fainthearted.

When one sets about introducing one person to another, attempting to carry that person into another's mind to open the way to intimacy, what one depends on is convention, a shorthand formula to span the chasm between people. "Peter, this is Jeffrey. He just moved into the neighborhood from Chicago, your old home town." "Melissa, I'd like you to meet Sandy. I gather you both have a passion for Bach." Conventions long standard in the Victorian period were sorely frayed by the time Woolf wrote *To the Lighthouse*, but she saw the need for them in any world in which people try to talk to each other: "A convention in writing," she wrote in "Mr. Bennett and Mrs. Brown,"

is not much different from a convention in manners. Both in life and in literature it is necessary to have some means of bridging the gulf between the hostess and her unknown guest on the one hand,

the writer and his unknown reader on the other. The hostess be-
thinks her of the weather, for generations of hostesses have estab-
lished the fact that this is a subject of universal interest in which we
all believe. She begins by saying that we are having a wretched May,
and, having thus got into touch with her unknown guest, proceeds
to matters of greater interest. So it is in literature. The writer must
get into touch with his reader by putting before him something
which he recognizes, which therefore stimulates his imagination,
and makes him willing to co-operate in the far more difficult busi-
ness of intimacy (CE 1:330–31).

Such conventions are shoddy tools under any circumstances, but they
are necessary in all. When Mrs. Ramsay's dinner party threatens to
dissolve into dissonance, convention is called in. "So, when there is a
strife of tongues, at some meeting, the chairman, to obtain unity, sug-
gests that every one shall speak in French. Perhaps it is bad French;
French may not contain the words that express the speaker's thoughts;
nevertheless speaking French imposes some order, some uniformity"
(TtL 135–36). So the modern writer, searching for a doorway into the
new world, must seek out what will at least serve as a substitute for
convention, for, as Woolf says, "At the present moment we are suffer-
ing, not from decay, but from having no code of manners which writ-
ers and readers accept as a prelude to the more exciting intercourse of
friendship" (CE 1:334).

The old forms, used in the old ways, may no longer work and
must, occasionally, be smashed if they are to be reworked at all into
the new; but if they are broken, they must be broken "not for the sake
of breaking, but for the sake of creating" (ROO 85), of making pos-
sible the difficult intercourse between writer and reader. All great
works, in any age, Woolf argues, snatch us beyond convention, make
us stretch to enter their worlds; and the symbolism in the hostess's
chat about the weather, in which the weather itself is of almost no
import, is a mere shadow of that denser, more exacting, more reveal-
ing symbolism that the artist will use in making his introductions to
the reader and then throwing open the fullness of his art to his new
friend. "For," says Woolf, "it is true of every object—coat or human

being—that the more one looks the more there is to see. The writer's task is to take one thing and let it stand for twenty: a task of danger and difficulty; but only so is the reader relieved of the swarm and confusion of life and branded effectively with the particular aspect which the writer wishes him to see" (CE 2:135). So, as we leave the welter of life outside, step off the street of our tangled lives and into the structured world of the novel, what can our hostess say to make us both feel at home and yet realize at the same time that she is introducing us into a universe in which character is complex and elusive, the world subject to change, and the challenge to the artist nearly overwhelming?

Well, to start off, as Woolf does in *To the Lighthouse* in her own peculiar way, she can follow the lead of her social counterpart and introduce the subject of the weather.

– A Reading –

— 5

INTRODUCTION
"My Dear, May I Introduce You to the Ramsays?"

To the Lighthouse is a novel written with fluidity yet structured with meticulous care. Its opening is meant to prepare us for all that is to come while keeping a sense of both the immediate and the universal, a difficult combination of objectives. If we look at the first five paragraphs briefly, we can watch the way that Virginia Woolf lifts us into her world with a scene that is both strange and familiar and that, in itself, sets up many of the themes to be developed in the novel that follows.

"'Yes, of course, if it's fine tomorrow,' said Mrs. Ramsay. 'But you'll have to be up with the lark,' she added" (TtL 9).

A cryptic opening. Woolf may, like the society hostess, begin by talking of the weather, but she does so in a way to suggest that we are not going to be able to depend on comfortable conventions to bring us into knowledge of her characters. She does not say, "My dear, let me introduce you to Mrs. Ramsay, a woman of quite remarkable beauty with a charismatic force of personality that allows her to unify the lives of her husband, eight children, and assorted guests into a harmonious whole while maintaining the strengths and the limitations of her Victorian perspective." Instead she drops us into the middle of

a conversation, as if we entered a crowded room invisibly, and lets us find our way toward an understanding of what is going on and who these people are. It is not going to be easy to sum these people up, we see.

But if part of the effect of this opening is to make the familiar strange, another is to lead us rapidly to the realization that we are being introduced to a conflict of views that needs resolving. "Yes," says Mrs. Ramsay, emphasizing the possibility of affirmation (and this "yes" is an addition to the first draft of the novel); "But," answers Mr. Ramsay, and goes on to deny that possibility. Yes. No. That is all we are given at the outset, in two brief statements that stand out as a frame to the second paragraph and so underscore the simple opposition the Ramsays declare. But by the time we have reached the end of the fifth paragraph, we are already beginning to understand that there is a symbolic weight to these polar views. "One cannot go to the Lighthouse," Mr. Ramsay seems to say, "because human beings are all islands and any dream of making connections, of realizing a vision, is illusory. We must face this fact bravely and insist on the truth of it, however painful." "Life is indeed difficult," Mrs. Ramsay might respond, "and people isolated in the storm, but connection must be made, bridges built, some hope offered. And it is the women especially who must reach out to the Lighthouse and bring solace, keep the promise of vision alive."

In the second paragraph this same conflict between severity and hope, bare truth and visionary possibility, is developed in a number of ways that define the course of the novel. To begin with, we see in James the fact that the two attitudes toward life may be present in one person, if unreconciled. For James, like his mother (as we gradually discover as the book unfolds), can endow a given moment with an emotional intensity and significance that takes it beyond its literal limits to become something crystallized and almost mystical. Yet he has his father's intense little blue eyes, "impeccably candid and pure, frowning slightly at the sight of human frailty" (TtL 10), so that we see the possibility (though he clearly fails to see it himself at this point, being fiercely on the side of his mother against his father) that in James

the opposition of the parents may be brought into harmony through human love, represented in successful marriage, which may be able to give birth to unity with the offspring it produces. We may even suspect (what is later confirmed) that this reconciliation may be accomplished if we can only get to the Lighthouse as in fact, after "years and years," condensed into "a night's darkness" (of "Time Passes") "and a day's sail" (during "The Lighthouse") we actually do (TtL 9).

But this presence of contradictions, begging for reconciliation, is not set before us merely in the characteristics given James but in the voice that presents them. Let us choose a bit of the second paragraph to watch the development of the opposing views: "since to such people even in earliest childhood any turn in the wheel of sensation has the power to crystallise and transfix the moment upon which its gloom or radiance rests, James Ramsay, sitting on the floor cutting out pictures from the illustrated catalogue of the Army and Navy Stores, endowed the picture of a refrigerator, as his mother spoke, with heavenly bliss" (TtL 9). The passage begins with intangible images, interconnecting to accomplish the impossible, to crystallize gloom, to transfix radiance, to give solidity (though of an abstract kind) to what is anything but solid, even, in the crystallizing of gloom, bringing together into one image both light and darkness. Then we leave the poetic, the intangible (Could anyone visualize this diamondlike gloom?) for the concrete, the matter-of-fact—James, the floor, the pictures, the particular catalogue—until we feel that we are down to earth at last. But just as we have the refrigerator firmly before us, the narrator, who has been arranging and ordering the phrases with great care, suddenly lifts us back into the poetic, and we shift abruptly from the refrigerator to heavenly bliss. A pattern of alternation, and eventual union, of the visionary and the concrete begins to seem possible. And the artist is the alchemist who works the wonder.[6]

It is the artist, too, who effects an actual reconciliation in these opening paragraphs, long before the characters she describes are aware that it is possible. In the fourth paragraph, we begin in the mind of James, who hates his father and thinks his mother "ten thousand times better in every way" (TtL 10). But by the end of the paragraph

we have moved (as the parentheses warn us, in case we have missed it) into the mind of Mr. Ramsay, who is bravely facing the fact "that life is difficult; facts uncompromising; and the passage to that fabled land where our brightest hopes are extinguished, our frail barks founder in darkness [Mr. Ramsay is partial to slightly sentimental poetry about bravery and to images of storm-tossed sailors] . . . one that needs, above all, courage, truth, and the power to endure" (TtL 11). How did we get from one mind to the other? Where did the transition take place? The answer is that there is no clear answer. We are not given any signal that a change is imminent, a move to be made. No "but," or "Mr. Ramsay, on the other hand," helps us make the leap. There is, in fact, no leap at all but only an unannounced slipping from one point of view into the other. Probably somewhere in the midst of the repeated, neutral assertions of Mr. Ramsay's truthfulness ("What he said was true. It was always true. He was incapable of untruth" [TtL 10–11]) the tone shifts, depending on how one chooses to read them, from fury to stoic integrity. In this gliding between the minds of James and his father, the artist's voice suggests a unity between them, a basic harmony of all people, that the angry James and the narrow-eyed Mr. Ramsay would find surprising at the very least.

So, in these opening pages, the reader is brought into the world of the Ramsays, introduced to the fact of opposition that is present in their midst, allowed to see that James may be one force to resolve this opposition and that the artist surely is another, and even given the hint that the voyage to the Lighthouse (and that is the title of the novel, after all) may indeed take place, if after some delay, allowing for the creation of a unity that only the artist herself can see at work here.

— 6

WHO ARE THESE PEOPLE?
The Novel as Biography

On 7 December 1925 Virginia Woolf confessed, parenthetically, in the midst of a diary entry, "how I begin to love the past—I think something to do with my book."[7] The book in question was *To the Lighthouse* and Woolf's developing affection for the past as she composed it was a sign of success in her coming to terms with two looming presences who had dominated her life and were, in a significantly altered form, to dominate the novel upon its completion. Two passages from "A Sketch of the Past," one of Woolf's autobiographical essays, written in the years just preceding her death, validate the assertion that *To the Lighthouse* is in some respects a sort of exorcism, and the contrasting figures of Mr. and Mrs. Ramsay interpretive portraits of Sir Leslie and Julia Stephen, Woolf's parents:

> Until I was in the forties—I could settle the date by seeing when I wrote *To the Lighthouse,* but am too casual here to bother to do it—the presence of my mother obsessed me. I could hear her voice, see her, imagine what she would do or say as I went about my day's doings. She was one of the invisible presences who after all play so important a part in every life.... It is perfectly true that she

obsessed me, in spite of the fact that she died when I was thirteen, until I was forty-four. Then one day walking round Tavistock Square I made up, as I sometimes make up my books, *To the Lighthouse*; in a great, apparently involuntary, rush. One thing burst into another. . . . I wrote the book very quickly; and when it was written, I ceased to be obsessed by my mother. I no longer hear her voice; I do not see her.

I suppose that I did for myself what psycho-analysts do for their patients. I expressed some very long felt and deeply felt emotion. And in expressing it I explained it and then laid it to rest. (MoB 80–81)

Further, just as I rubbed out a good deal of the force of my mother's memory by writing about her in *To the Lighthouse,* so I rubbed out much of his [her father's] memory there too. Yet he too obsessed me for years. Until I wrote it out, I would find my lips moving; I would be arguing with him; raging against him; saying to myself all that I never said to him. How deep they drove themselves into me, the things it was impossible to say aloud. (MoB 108)

By the time the conception of *To the Lighthouse* was completed, these two powerful figures from Woolf's past had been brought into some sort of balance, so that although Mrs. Ramsay still tends to form the center of much of the book, Woolf's aim is clear, as she notes it directly in the brief outline that opens the manuscript draft of the novel: "The theme of the 1st part shall *really* contribute to Mrs. R's character; at least Mrs. R's character shall be displayed, but finally . . . in conjunction with his, so that one gets an impression of their relationship" (TtLd 2). Already the focus is on a connection between the two characters, significantly given no first names so that they may be seen as halves of one indivisible whole; yet for at least one of Woolf's early readers the individual natures of Mrs. and Mr. Ramsay and their vividness as portraits were the most telling aspect of Woolf's novel. Vanessa Bell, writing to her sister after just having finished reading *To the Lighthouse* for the first time, tried initially to respond to it with the aesthetic judgment appropriate to her role as artist but quickly gave up and said:

Anyhow it seemed to me in the first part of the book you have given a portrait of mother which is more like her to me than anything I could ever have conceived of as possible. It is almost painful to have her so raised from the dead. You have made one feel the extraordinary beauty of her character, which must be the most difficult thing in the world to do. It was like meeting her again with oneself grown up & on equal terms & it seems to me the most astonishing feat of creation to have been able to see her in such a way—You have given father too I think as clearly, but perhaps, I may be wrong, that isnt [sic] quite so difficult. There is more to catch hold of. Still it seems to me to be the only thing about him which ever gave a true idea. So you see as far as portrait painting goes you seem to me to be a supreme artist & it is so shattering to find oneself face to face with those two again that I can hardly consider anything else.[8]

For both Virginia Woolf and her sister, the portrayal of their parents resulted in what one might call emotional portraits as much as literal ones. Expressing, and explaining, the effect that Sir Leslie Stephen and his wife had on those around them and then bringing the powerful, often contradictory responses into balance, that was in part the aim of the novel. It was a difficult task, for few can perceive their parents unclouded by a swirl of tumultuous emotional fog, and Sir Leslie and Julia Stephen called up feelings in their children as passionate as those exhibited by James in the opening pages of *To the Lighthouse*.

Because for Virginia and Vanessa, as well as for most readers, the figure of Sir Leslie Stephen, as transformed into Mr. Ramsay, seems a little less dominant than that of his wife, it might be well to start with him in order to see how the portrait matches the original.

In his day, Sir Leslie Stephen, as his title indicates, was a man of considerable eminence, renowned as a literary critic and historian, a frequent companion of the most famous men of his day. But it was not the public figure whom Virginia Woolf knew when he was alive, as she admits in "A Sketch of the Past": "when Nessa and I inherited the rule of the house, I knew nothing of the sociable father, and the writer father was much more exacting and pressing than he is now

that I find him only in books; and it was the tyrant father—the exacting, the violent, the histrionic, the demonstrative, the self-centered, the self pitying, the deaf, the appealing, the alternately loved and hated father—that dominated me then" (MoB 116). Rage alternating with love, these were the emotions that defined Woolf's relation to her father. The need to see both in perspective, and understand both, lies behind much of the portrayal of Mr. Ramsay.

The love Woolf felt for her father was real, but it was not her dominant feeling toward him, in part because his abusive behavior to the women in his life called up such anger, but also because his general character did not often touch Woolf into affection. She saw him, all her life, as something of a type, one that for her lacked "picturesqueness, oddity, romance. That type is like a steel engraving, without colour, or warmth or body; but with an infinity of precise clear lines." She admires the precision of such people: "I respect them, I say; I admire their honesty, their integrity, their intellect" (MoB 109). But respect and admiration are not love; they do not "catch the imagination," as she puts it. Even Sir Leslie's intellect did not inspire her with awe, a more powerful emotion than respect. What she found in it was "not a subtle mind; not an imaginative mind; not a suggestive mind. But a strong mind; a healthy out of door, moor striding mind [and already the resemblance to Mr. Ramsay with his long walks and his imaginings of great expeditions begins to emerge]; an impatient, limited mind; a conventional mind entirely accepting his own standard of what is honest, what is moral" (MoB 115).

The strengths and limitations of her father's mind Woolf sums up in "A Sketch of the Past": "Give him a thought to analyse, the thought say of Mill or Bentham or Hobbes [the subject of Mr. Ramsay's own ruminations], and he is . . . a model of acuteness, clarity, and impartiality. Give him a character to explain, and he is (to me) so crude, so elementary, so conventional that a child with a box of chalks could make a more subtle portrait" (MoB 146). This limit to the rational kept her father, as she saw him, from any appreciation of the aesthetic aspects of life that were so important to her. He was, she says, "spartan, ascetic, puritanical. He had I think no feeling for pictures; no ear

for music; no sense of the sound of words" (MoB 68). Yet even as she dwells on the narrowness of his vision, his embodiment of a certain, limited, superrational temperament, she admits her bias: "Undoubtedly I colour my picture too dark, and the Leslie Stephen whom the world saw in the eighties, and in the nineties until my mother died, must have been not merely a Cambridge steel engraving intellectual" (MoB 113).

What, then, carried him beyond being simply an exemplification of the rational man? Not, as we have seen already, a secret fund of sensitivity to the more intuitive side of life. Instead, it was a "frustrated desire to be a man of genius, and the knowledge that he was in truth not in the first flight—a knowledge which led to a great deal of despondency, and to that self-centredness which in later life at least made him so childishly greedy for compliments, made him brood so disproportionately over his failure and the extent of it and the reasons for it" (MoB 110)—these were the qualities that broke up the fine steel engraving, qualities that are carried over into his fictional counterpart. Thus he avoided one type only to be transformed into another. "We made him," says Woolf, "the type of all that we hated in our lives; he was the tyrant of inconceivable selfishness, who had replaced the beauty and merriment of the dead [her mother] with ugliness and gloom" (MoB 56). Though Woolf admits to a certain injustice in this picture, when she looks back to the results of his self-centeredness, his histrionic scenes over the weekly bills, for example, she says, long after his death, "Even now I can find nothing to say of his behaviour save that it was brutal. If instead of words he had used a whip, the brutality could have been no greater" (MoB 145). And the element of this brutality that stayed fixed most firmly in her mind was that it was limited to the women in his life. She can explain that aberration—"woman was then (though gilt with an angelic surface) the slave" (MoB 145) and only to a woman could he reveal his sense of his own failure and demand sympathy and consolation to mask that failure, since to a man such revelations would seem unmanly—but the pain it inflicted remained.

This side of Sir Leslie, the insecure, demanding man, is confirmed

by Noel Annan in his basically sympathetic biography in which he explains Stephen's passion for mountaineering as "rationalization of a more deep-seated fear: a doubt whether he was capable of achieving anything"[9] and even by Sir Leslie himself, when he writes in his memoirs: "I used sometimes I must confess . . . to profess a rather exaggerated self-depreciation in order to extort some of her [his wife's] delicious compliments."[10] But for all the misery inflicted by the limited side of his character, Sir Leslie was not incapable of evoking loyalty and affection from his daughter. "I too felt his attractiveness," writes Woolf. "It arose—to name some elements at random—from his simplicity, his integrity, his eccentricity—by which I mean he would say exactly what he thought, however inconvenient [and the phrasing evokes Mr. Ramsay in the opening scene of the novel]; and do what he liked. He had clear, direct feelings" (MoB 111). So among "his obvious qualities," beyond the less attractive ones, were "his honesty, his unworldliness, his lovableness, his perfect sincerity" (MoB 110). And there were times when he called up in his children the most passionate and positive feelings: "Beautiful was he at such moments; simple and eager as a child; and exquisitely alive to all affection; exquisitely tender. We would have helped him then if we could, given him all we had, and felt it little beside his need—but the moment passed" (MoB 46).

It is significant, in the rhythm of the novel, given the great weight in Woolf's autobiographical account of her father accorded to his negative traits, that our last glimpse of Mr. Ramsay is of one of these tender moments in which his sincerity, integrity, and gentleness lead his children to feel, "What do you want? . . . They both wanted to say, Ask us anything and we will give it to you" (TtL 307–8). For it is an emotional balance that is needed for the exorcism of rage, and a view, in perspective, of the whole man.

Ambivalence is at the heart of Woolf's feelings toward her father. Yet her portrait of Mr. Ramsay succeeds in presenting us with both his limited mind, his need for sympathy, his leechlike attachment to women, and his ill temper, as well as his honesty, sincerity, integrity, courage, and capacity for tenderness. Given this objective balancing

of elements, it is not surprising that, even in a portrait defined so much by emotion, the quirks and qualities of the external man, that aspect that appears on the surface and beneath which the emotions are hidden, should emerge also. Thus a contemporary acquaintance of Sir Leslie Stephen who knew nothing of his private moanings and rages might well still have recognized him in Woolf's novel. Some telling characteristics, slipped into the text, are worth noting.

As founder and editor of the *Dictionary of National Biography*, Sir Leslie Stephen did indeed approach truth alphabetically and stop short in his work before he got to the volume containing Z. But then, as Quentin Bell points out, he "would rather have been remembered as a philosopher,"[11] anyway, and a philosopher, in *To the Lighthouse*, he is. At home, Sir Leslie showed a fondness for the novels of Sir Walter Scott and would read them aloud to his children, all thirty-two volumes, "which once he had completed he would begin again at the first";[12] so it comes as no surprise to find Mr. Ramsay indulging in *The Antiquary*. At the university, in his lecturing, he "loved to talk, as he put it, nonsense to undergraduates,"[13] and that phrase moves directly into Mr. Ramsay's description of his own plans for a visit "to talk 'some nonsense' to the young men of Cardiff about Locke, Hume, Berkeley, and the causes of the French Revolution" (TtL 70).

The concern with fame, tangled up both in Mr. Ramsay's venturing into Scott and in his academic life, was admitted by Sir Leslie himself in his sketch of his own past that has come to be known as the *Mausoleum Book*: "a man of genius might be lucky were he remembered for 1000 years; and what, as the psalmist asks, is a thousand years? . . . Had I—as I often reflect—no pretext for calling myself a failure, had I succeeded in my most ambitious dreams and surpassed all my contemporaries in my own line, what should I have done? I should have written a book or two which would have been admired by my own and perhaps the next generation."[14] Then Mr. Ramsay echoes: "It is permissible even for a dying hero to think before he dies how men will speak of him hereafter. His fame lasts perhaps two thousand years. And what are two thousand years?" (TtL 56).

Odd habits or mannerisms of Sir Leslie appear in Mr. Ramsay,

and these descriptions of her father from Woolf's memoirs apply equally well to her fictional philosopher: "He was a curious figure thus sitting often dead silent at the head of the family dinner table. . . . He would ask what was the cube root of such and such a number" (MoB 111). Again at dinner, he would be pacified by some compliment or opinion from a pretty young woman (Kitty Lushington in life, Minta Doyle in fiction), for he "was extremely sensitive to female charm" (MoB 165). "And out of doors he strode along, often shaking his head emphatically as he recited poetry, and giving his stick a flourish" (MoB 113). He even twisted a lock of his hair, a habit his daughter adopted until broken of it by her mother, and Mr. Ramsay does the same. But perhaps the most powerful scene in which the two men are conflated is that contained in the stark brackets within "Time Passes." Here is the nonfictional version: "My father staggered from the bedroom as we came. I stretched out my arms to stop him, but he brushed past me, crying out something I could not catch; distraught. And George led me in to kiss my mother, who had just died" (MoB 91). Subtle differences between this account and the passage in *To the Lighthouse* begin to suggest what will become clearer as we enter more deeply into the novel—that biography, or portraiture, is only a useful tool for a larger purpose. But there is no doubt that Sir Leslie Stephen, if significantly altered, walks the garden paths of *To the Lighthouse*.

If Sir Leslie Stephen was an important figure in the life of Virginia Woolf and the creation of Mr. Ramsay an exercise necessary for her to come to terms with her anger at him and let his more positive aspects rise to the surface above those that caused her pain, there is little doubt that Julia Stephen, Woolf's mother, obsessed Woolf even more and loomed larger in her vision of the past. It demanded an intense effort on her part to place that magical, powerful figure in the context of her youth and even, as she wrote *To the Lighthouse*, of her present. Woolf's first memory was of her mother (MoB 64). Julia Stephen occupied so large a place in Woolf's childhood that she evoked in her decidedly non-Christian daughter religious images that stayed with her into Woolf's novel. "Certainly there she was," says Woolf, "in the

very centre of that great Cathedral space which was childhood; there she was from the very first" (MoB 81). Again and again that concept of the center recurs in Woolf's memories of her. "I suspect the word 'central' gets closest to the general feeling I had of living so completely in her atmosphere that one never got far enough away from her to see her as a person," she says; "She was the whole thing" (MoB 83). On 5 May 1895, the day of her death, that center fell apart; and it would take years before Woolf could gain the perspective she needed to perceive her mother as an individual, to understand her as a person. Even in 1907, Woolf was seeing her larger than life: "But now and again on more occasions than I can number, in bed at night, or in the street, or as I come into the room, there she is; beautiful, emphatic, with her familiar phrase and her laugh; closer than any of the living are, lighting our random lives as with a burning torch, infinitely noble and delightful to her children" (MoB 40). Nearly twelve years after her death, and sixteen before the conception of *To the Lighthouse,* Julia Stephen was present in her daughter's imagination like some mystical force, associated, as her fictional counterpart, with the infinite and with some illuminating beacon.

What was she like, this center of a family life "very merry, very stirring, crowded with people" (MoB 84)? In Woolf's "Reminiscences," written for her nephew-to-be in 1907, that question is already being addressed: "she was not only the most beautiful of women as her portraits will tell you, but also one of the most distinct. Her life had been so swift, it was to be so short, that experiences which in most have space to expand themselves and bear leisurely fruit, were all compressed in her" (MoB 32). Years later, not long before Woolf's death, the question is asked again: "But apart from her beauty, if the two can be separated, what was she herself like?" and the answer offered a little more objectively: "Very quick; very direct; practical; and amusing. . . . Severe; with a background of knowledge that made her sad" (MoB 82). Whatever the answer, one element of Mrs. Stephen's life, one that is a part of Mrs. Ramsay as well, is an intensity that grows out of a sense of time's passing: "She kept herself marvellously alive to all the changes that went on round her, as though she

heard perpetually the ticking of a vast clock and could never forget that some day it would cease for all of us" (MoB 35).

Born of this watchfulness and awareness of mortality were both a sense of mystery and a sense of responsibility that would later be manifest in Mrs. Ramsay. Mrs. Stephen "seemed to watch, like some wise Fate, the birth, growth, flower and death of innumerable lives all round her, with a constant sense of the mystery that encircled them . . . and a perfectly definite idea of the help that was possible and of use. Her intellectual gifts had always been those that find their closest expression in action; she had great clearness of insight, sound judgement, humour, and a power of grasping very quickly the real nature of someone's circumstances, and so arranging that the matter, whatever it was, fell into its true proportions at once" (MoB 34–35). Like Mrs. Ramsay, Julia Stephen, as Woolf saw her, was capable of revealing by her very presence some order behind the flux: "All lives directly she crossed them seemed to form themselves into a pattern and while she stayed each move was of the utmost importance" (MoB 35).

Amid all this sensitivity to those around her, Julia Stephen never seemed "troubled to consider herself at all" (MoB 34). Her life, quite consciously, was spent in service to others, and with her temperamental husband, her three children by her first marriage and the one by his, her four children from her marriage to Sir Leslie, and countless needy friends and family members, there was little time to think of herself. "Anyone coming for help," writes her daughter, "found her invincibly upright in her place, with time to give, earnest consideration, and the most practical sympathy" (MoB 34). As her husband put it in his memoirs: "She thought pain so common that she was bound to seize every chance of alleviating suffering or promoting happiness."[15] "She visited the poor, nursed the dying, and felt herself," says Woolf, "possessed of the true secret of life at last, which is still obscured from a few, though they too must come to know it, that sorrow is our lot, and at best we can but face it bravely" (MoB 32). Mrs. Ramsay enacts this same practical compassion in To the Lighthouse, but by the time it manifests itself there it is treated with a mixture of

admiration and skepticism as Lily and Mr. Carmichael, in unspoken resistance, express some doubt about her instinct to rush in to succor the human race. "Some notion was in both of them about the ineffectiveness of action, the supremacy of thought." Yet even as they draw together in their cynicism, they feel that "[h]er going was a reproach to them" (TtL 291–92). For Mrs. Stephen's sympathy and care for others inspired awe even in those who chose another role.

It was a heavy burden she carried, this responsibility for all those in need; and ever since the death of her first husband she refused to cast any of it on God, becoming, like Mrs. Ramsay, the most positive of disbelievers (MoB 32). It was the pain of the world that destroyed her faith, as it has that of others. Thus Mrs. Ramsay's cry might well have been hers: "How could any Lord have made this world? . . . With her mind she had always seized the fact that there is no reason, order, justice: but suffering, death, the poor. There was no treachery too base for the world to commit; she knew that. No happiness lasted; she knew that" (TtL 98). The burden wore her down until she drew near that point of sinking experienced by Mrs. Ramsay as she faces the task of creating unity at her singularly discordant dinner table. Even the images Woolf uses to describe her mother's gradual collapse slip into Mrs. Ramsay's mind. Mrs. Stephen "sank, like an exhausted swimmer, deeper and deeper in the water, and could only at moments descry some restful shore on the horizon to be gained in old age when all this toil was over" (MoB 39). So Mrs. Ramsay "began all this business, as a sailor not without weariness sees the wind fill his sail and yet hardly wants to be off again and thinks how, had the ship sunk, he would have whirled round and round and found rest on the floor of the sea" (TtL 127).

Among the memories of her mother, there are few to darken her image in Woolf's mind. There is one poignant moment in "A Sketch of the Past" in which Woolf admits that her mother "was living on such an extended surface that she had not time, nor strength, to concentrate, except for a moment if one were ill or in some child's crisis, upon me, or upon anyone—unless it were Adrian. Him she cherished separately; she called him 'My Joy'" (MoB 83). This feeling of being

outside her mother's center of focus (and Mrs. Stephen did seem to direct her attention more tenderly toward her sons than toward her daughters) may have some bearing on Woolf's own ill health but does not seem to affect the glowing concept of her mother as she appears as Mrs. Ramsay. Yet even in "Reminiscences," which was written when Woolf was most strongly under her mother's spell, there is just a hint of an intimidating and domineering side to Mrs. Stephen that is worked into the pattern of Woolf's novel later: "She was impetuous, and also a little imperious," Woolf writes in her early portrait; "so conscious of her own burning will that she could scarcely believe that there was not something quicker and more effective in her action than in another's" (MoB 39). Or again, "Sometimes . . . she took it on herself to despatch difficulties with a high hand, like some commanding Empress." But even this criticism is quickly counterbalanced by praise; "most often I think her service, when it was not purely practical, lay in simply helping people by the light of her judgement and experience to see what they really meant or felt" (MoB 35), a characteristic not only of the sensitive counselor but of the artist, as conceived by Woolf and her friends.

It is more than a little interesting, given the importance of various sorts of art and artistry in *To the Lighthouse,* that Woolf often thought of her mother as a subject for the artist, saying, for example, "if one could give a sense of my mother's personality one would have to be an artist. It would be as difficult to do that, as it should be done, as to paint a Cézanne" (MoB 85). Since Cézanne was the chief of the postimpressionists and, as such, a strong influence, indirectly, on the subject of art itself in *To the Lighthouse,* the analogy carries particular weight. Throughout her memoirs Woolf places her mother in little scenes that Mrs. Ramsay occupies under the eye of the painter Lily Briscoe: "I see her going to the town with her basket; and Arthur Davies goes with her; I see her knitting on the hall step" (MoB 84).

Other scenes and characteristics too, beyond the scope of the visual artist, move easily from the daily life of Mrs. Stephen to that of Mrs. Ramsay: those moments "so soothing yet exciting when one ran downstairs to dinner arm and arm with mother; or chose the jewels

she was to wear" (MoB 95), as Rose Ramsay does for her mother; the charismatic power that led some to accuse Mrs. Stephen of stealing the affection of other people's children (MoB 102), as someone accuses Mrs. Ramsay; and, perhaps most important for the novel, that insistence on the necessity for marriage, which led to a passion for matchmaking that even her husband made note of in his *Mausoleum Book*.[16] Some powerful influences in the life of Mrs. Stephen do not make their way directly into the novel, most notably the death of her first husband about whom she spoke little but whom she idealized (MoB 33) and whose death became for her the image of the world's sorrow. But even this experience seems to have created an unspecified mystery in the life of Mrs. Ramsay, which leads the narrator to ask, "What was there behind it—her beauty and splendour? Had he blown his brains out, they asked, had he died the week before they were married—some other, earlier lover, of whom rumours reached one?" (TtL 46).

Small wonder that so beautiful, so charismatic, so sympathetic a woman, one who defined Virginia Woolf's childhood and gave it its life and its joy before suddenly dying and leaving a void filled only with the melodramatic grief of her husband, small wonder that such a figure should have shone out in Woolf's life like the "silvery, misty-looking" (TtL 270) light of the Lighthouse.

Yet if she had remained "the whole thing," as Woolf saw her as a child, Woolf's life would have suffered from an imbalance that might well have interfered with her art as effectively as her father's lack of an aesthetic sense, coupled with his narrow views of the proper role for woman, as servant of man, would have interfered had he lived much longer than he did. Some perspective was needed to balance the characteristics of both her parents in Woolf's mind, and it is their relationship as much as their individual attributes that creates a foundation for *To the Lighthouse*.

In "Reminiscences," Woolf presents her parents' marriage as "the true though late fulfilment of all that [her mother] could be" (MoB 33) and goes on to say to her nephew, as yet unborn, "the relationship between your grandfather and mother was, as the saying is, perfect, nor would I for a moment dispute that, believing as I do that each of

these much tried and by no means easy-going people found in the other the highest and most perfect harmony which their natures could respond to. . . . But, if I can convey my meaning by the metaphor, the high consonance, the flute voices of two birds in tune, was only reached by rich, rapid scales of discord, and incongruity" (MoB 37). Perfection contains within it imperfection as an essential element. A positive view of marriage does not gloss over the presence of conflict. Perhaps because Woolf seemed able to recognize the tension in her parents' relationship even as she declared its essential equilibrium, she maintains the musical metaphor in creating her picture of the Ramsays' marriage in which the role of opposition is far more strongly put than in her earlier family memoir: "Every throb of this pulse seemed, as he [Mr. Ramsay] walked away, to enclose her and her husband, and to give to each that solace which two different notes, one high, one low, struck together, seem to give each other as they combine" (TtL 61).

The quality that seemed to hold together these two very different people was a mutual admiration, Mrs. Stephen standing in awe of her husband's intellect, Sir Leslie doing homage to his wife's goodness and intuitive powers. When describing her mother's respect for Sir Leslie's talents in "Reminiscences," Woolf presents it in terms that would slip easily into *To the Lighthouse,* in which Mr. Ramsay's intellectual adventures are presented in the same images of sea journeys and mountaineering: "his age was made emphatic by the keen intellect, always voyaging, as she must have thought, alone in ice-bound seas. Her pride in it was like the pride of one in some lofty mountain peak, visited only by the light of the stars, and the rain of snow" (MoB 37). Sir Leslie's pride in his wife, too, is offered in language that is echoed in the novel: "how sweet, released from the agony and loneliness of thought to recognize instantly the real presence of unquestionable human loveliness! as a seafarer wrapt for many days in mist on the fruitless waters lands at dawn upon a sunlit shore, where all nature enfolds him and breathes in his ear rest and assurance" (MoB 37–38). So Sir Leslie, as Woolf perceived him, could rest in the creative atmosphere his wife embodied, and she, "whose days were spent in labours often

trifling, and often vain, exulted as one clasped suddenly in strong arms and set above it all, silent, still and immortal" (MoB 38); similarly Mrs. Ramsay, "whose day had slipped past in one quick doing after another" (TtL 28), finds "a Heaven of security" (TtL 51) in her husband's unflinching intellectual integrity. The mutual homage and respect that the Stephens felt for one another is confirmed by Sir Leslie in his *Mausoleum Book,* where the complementary strengths of the two are summed up in this word of praise: "Her instincts were far more to be trusted than my ratiocinations."[17]

A few idiosyncratic elements in the relationship between the Stephens make their way into Woolf's novel, too; for example, Sir Leslie's neurosis about money, disturbing to his wife, emerges in the bill to mend the greenhouse that Mrs. Ramsay is reluctant to mention to her husband. But one matter bears special mention since it holds an important place in *To the Lighthouse* and has been the subject of some controversy among critics. "After our marriage," writes Sir Leslie, "I used sometimes to complain to [my wife] that she would not say to me in so many words, "I love you." . . . My complaint was only in play for I loved even her reticence. In truth, husband and wife, living together as we did in the most unreserved intimacy, confiding to each other every thought and feeling as it arises, do not require the language of words. In every action, in her whole conduct, she showed her love; it shone through her life; and the use of a set of words was a trifle."[18] So when Mrs. Ramsay expresses her love for her husband in any way she can, save for words, and feels she has succeeded in conveying what she cannot say, we may rest in the conviction that Woolf believed such unspoken communication both possible and effective.

Since some of Woolf's warmest and most illuminating childhood memories, several of which took on an almost mystical aura in her life, were of time spent at Talland House on the coast of Cornwall, the family's summer home, it is not surprising that Woolf chose this setting, only thinly disguised in being transported to the Hebrides, for the shaping of her past into a work of art. Nor is it surprising that people from that past, other than the figures of her parents, should appear walking the paths of the Talland House gardens or setting sail

for Godrevy Lighthouse (in the novel significantly moved from the shore to an island in the bay). For example, Mr. Wolstenholme, an elderly mathematician and poet who had made a bad marriage and who stayed each summer at Talland House, where he could escape from his wife and indulge in opium, is a clear model for Mr. Carmichael,[19] though in the novel he is not the comic figure that Woolf pictures him in her memoirs. Kitty Lushington, who would charm Sir Leslie at dinner, got engaged to Leo Maxse under the jacmanna in the Talland House gardens and probably served as the inspiration for Minta Doyle. Engagements had a magical force for Woolf, and that between Stella Duckworth and Jack Hills seems to have given her some of the imagery with which she describes Minta and Paul as they glow with their new love at the Ramsays' table. "It was through that engagement," she writes, "that I had my first vision—so intense, so exciting, so rapturous was it that the word vision applies—my first vision then of love between man and woman. It was to me like a ruby; the love I detected that winter of their engagement, glowing, red, clear, intense" (MoB 105).

Woolf's own reactions to events in her past often appear in *To the Lighthouse* and are shared among a number of the characters. So Mrs. Ramsay and Lily, though with a difference, experience new love as she did. And Cam is afraid of the shadows cast on the nursery wall by the boar's skull just as Woolf was afraid if the nursery fire burned too high and sent its flame flickering over the wall. (Adrian liked the fire, and their nurse folded a towel over the fender as a compromise, as Mrs. Ramsay wraps the skull in her shawl to satisfy both Cam and James [MoB 78].) Then Mrs. Stephen would sit on the edge of her daughter's bed and tell her to think of all the lovely things she could imagine—"Rainbows and bells . . ." (MoB 82; ellipses are Woolf's)—as Mrs. Ramsay does for Cam. It is Cam, too, who expresses Woolf's own ambivalence about the Sir Leslie figure in her life: "For no one attracted her more. . . . But what remained intolerable . . . was that crass blindness and tyranny of his which had poisoned her childhood and raised bitter storms, so that even now she woke in the night trembling with rage and remembered some command of his; some insolence" (TtL 253).

Even the crucial sail to the Lighthouse had its counterpart in Woolf's past, as she reported in the *Hyde Park Gate News,* the family newspaper she wrote herself, on 12 September 1892. "On Saturday morning Master Hilary Hunt and Master Basil Smith came up to Talland House and asked Master Thoby and Miss Virginia Stephen to accompany them to the light-house as Freeman the boatman said that there was a perfect tide and wind for going there. Master Adrian Stephen was much disappointed at not being allowed to go."[20] The image of Thoby, "steering us round the point without letting the sail flap" is one that stayed with Woolf all her life, for it captured not only his own feelings but also the pressure Sir Leslie put on all his children. Thoby "looked sulky; grim; his eyes became bluer when he was thus on his mettle; his face flushed a little. He was feeling earlier than most boys, the weight laid on him by father's pride in him; the burden, the responsibility of being treated as a man" (MoB 136). Yet it was not Thoby who felt a strange kinship with his father, but Woolf herself. "I felt his presence," she wrote, "and had many a shock of acute pleasure when he fixed his very small, very blue eyes upon me and somehow made me feel that we two were in league together. There was something we had in common" (MoB 111). This feeling is given in the novel to James.

It is here that we must stop and point out directly what has been growing more evident all along, that although there is much in *To the Lighthouse* that must be seen as having its roots in autobiography, the branches and the fruit are fiction. It is not by accident but by design that Mr. Carmichael is not, as his model was, a figure of fun, that the Lighthouse has been moved into the bay. Save for a few superficial changes, most of the alterations Woolf made in transforming life to art are of considerable importance to the larger themes of the novel and allow her to convey, through a certain detachment, the universal import of the scene before her as Lily Briscoe, distanced like Woolf through time, can do with her painting.

As the novel grew from draft to finished work, Woolf introduced characteristics in her two main characters, Mrs. Ramsay and Mr. Ramsay, that separate them from any one real-life model and allow them to become representative of larger truths about life, as she saw

it, than any mere portrait could contain. Mrs. Ramsay loses Mrs. Stephen's identifying laugh (TtLd 312) and unlike Mrs. Stephen does not protest, "no mathematics . . . at meals" (MoB 111), when Mr. Ramsay talks about square roots, for she is not meant to be as idiosyncratic a woman as the laugh might suggest but is meant to rest in delight on the measurable truth that a square root can stand for, the sort of truth embodied in the universal male, and to contain in herself the emotional vibrancy that belongs to the universal female. That is why it is Mrs. Ramsay who worries that her children may be injured or drowned during their walk on the beach. In real life it was Sir Leslie, not his wife, who harbored such fears, as Woolf points out in her essay about him: "neither his reason nor his cold common sense helped to convince him that a child could be late for dinner without having been maimed or killed in an accident" (CE 4:78). But Mr. Ramsay, save for his emotional dependency on his wife, must stand for reason.

Another interesting shift of emphasis in the novel is in the role played by Sir Walter Scott, for although Sir Leslie read his works aloud, it was Mrs. Stephen who had the real passion for him (MoB 86). The choice of reading, as we shall see later in more detail, is of great importance in defining the essential qualities of Mr. and Mrs. Ramsay; and Mrs. Ramsay is clearly meant to emerge as the person more sensitive to the incandescent quality of the greatest art. So she reads Shakespeare; for Woolf, although confessing to Scott's good qualities, did not think him one who could, like the true artist, offer the reader "the essence sucked out of life" (TtL 181). "This lazy-minded man," she writes of him, "was quite capable when the cold fit was on him of filling a chapter or two currently, conventionally, from a fountain of empty, journalistic phrases which, for all that they have a charm of their own, let the slackened attention sag still further" (CE 2:67). He could be sentimental, and his love scenes were absurd. Mr. Ramsay can be sentimental, too, and is not nearly so in awe of genuine love as his wife. So he must read Scott, and not his wife, although Mrs. Stephen would have been happy to do so.

One figure in *To the Lighthouse* who is as important as the Ram-

says is Lily Briscoe. Her presence alone carries the novel away from autobiography, for she has no clear model in the Talland House world at all. In part, of course, as Woolf suggested, she is Vanessa, whose paintings resembled Lily's and whom Woolf praised for her honesty of mind. "She might not see all, but she would not see what was not there" (MoB 30) just as Lily refuses to see the jacmanna as any less purple than her eyes perceive it. But she is also Roger Fry, who had a show of his work in 1920 that was a complete failure, so that he wrote to a friend, "I will go on painting, and when the canvases are dry, I will roll them up,"[21] while Lily imagines her own canvases "rolled up and stuffed under a sofa" (TtL 237). (Later, when we look at the subject of art in Fry's theory and Woolf's novel, we shall notice other deeper connections between Fry and Lily.) And she is Virginia herself. She completes her painting when she is forty-four, after gaining, through time, the perspective she needs to see Mrs. Ramsay clearly, as Woolf was forty-four when she finished *To the Lighthouse*, her own exercise in putting her parents in perspective. Even the imagery for Lily's ideal vision of her painting, "the colour burning on a framework of steel; the light of a butterfly's wing lying upon the arches of a cathedral" (TtL 75), seems to have come from a moment of illumination Woolf experienced shortly after her mother's death. "It was sunset, and the great glass dome at the end of the station was blazing with light. It was glowing yellow and red and the iron girders made a pattern across it. I walked along the platform gazing with rapture at this magnificent blaze of colour. . . . It impressed and exalted me" (MoB 93).

So Woolf, in writing *To the Lighthouse*, was using her parents and her past as models, but was attempting something far more exalted, more universal, than mere portraiture.

— 7

WHO ARE
THESE PEOPLE?
Victorians, Edwardians,
and Woolf's Woman Question

Sir Leslie Stephen and his wife, from their portrayal in Virginia Woolf's earliest memoirs and on, tend to assume mythic proportions, to become types of selfishness and unselfishness, isolation and unity, or other human qualities that stood out in Woolf's daily life. But for all her involvement in the emotional atmosphere her parents created, Virginia Woolf, by the time she conceived *To the Lighthouse,* was able to see them in a way that extended far beyond the limited vision of her childhood and to transform them into types that transcended the personal. For Mr. and Mrs. Ramsay, from their initial position as portraits of two individual, idiosyncratic people, soon become embodiments of the Victorian Age and the younger people who surround them representatives of the age that followed.

Early critics of Virginia Woolf often accused her of being an elitist, of including in her art only a sliver of life—intellectual, upper-middle-class, aesthetic—and omitting anything that took place outside the impressionistic world of the mind. But Woolf was keenly aware of the outer world and the role it played in shaping all aspects of experience, including those of art and of thought. "Consider what immense forces society brings to play upon each of us," she wrote in "A Sketch

of the Past"; "how that society changes from decade to decade" (MoB 80). She often looked at the events and scenes around her to see what sort of society they revealed, and the society contained within the walls of 22 Hyde Park Gate, where she lived as a child, had a distinctive form indeed. "If I had the power to lift out of the past a single day as we lived it about 1900," she wrote, "it would give a section of upper middle class Victorian life, like one of those sections with glass covers in which ants and bees are shown going about their tasks" (MoB 147). Yet inherent in this bell-jar world was a tension that prepared the way for the coming of a new era. "Two different ages confronted each other in the drawing room at Hyde Park Gate. The Victorian age and the Edwardian age," she wrote, thinking particularly of the positions that she and Vanessa held in that house. "But while we looked into the future, we were completely under the power of the past. Explorers and revolutionists, as we both were by nature, we lived under the sway of a society that was about fifty years too old for us. It was this curious fact that made our struggle so bitter and so violent. For the society in which we lived was still the Victorian society. Father himself was a typical Victorian. . . . We were living say in 1910; they were living in 1860" (MoB 147). Nineteen ten, the year that human character changed, set in the midst of Victoria's reign. This opposition between the two eras, which Woolf and her sister felt so strongly in their own lives, is one of the major themes of *To the Lighthouse*.

What characterized the Victorian world as Virginia Woolf saw it? What strictures did it place on the individual? In "A Sketch of the Past" she offers an answer that is central to her novel: "Society in those days was a very competent machine. It was convinced that girls must be changed into married women. It had no doubts, no mercy; no understanding of any other wish; of any other gift."[22] We have already noted that Mrs. Stephen was known as a matchmaker. In Mrs. Ramsay this habit of mind becomes an immense force in her relationship with Lily Briscoe, who offers this picture of her older friend: "she would . . . insist that she [Lily] must, Minta must, they all must marry, since in the whole world whatever laurels might be tossed to her (but

Mrs. Ramsay cared not a fig for her painting) . . . there could be no disputing this: an unmarried woman (she lightly took her hand for a moment), an unmarried woman has missed the best of life" (TtL 77). In keeping with this limited view of appropriate female roles, neither Sir Leslie Stephen nor his wife "cared for emancipated women."[23] He would not vote to grant women full membership in his university, and she signed an Appeal against Female Suffrage, considering it "a woman's duty . . . to serve—to serve her husband, her children, her parents and kinsmen and those in need."[24] This insistence on the proper role for women that was common to many people of both sexes in the Victorian Age is carried over into the views of both Mr. and Mrs. Ramsay.

Mr. Ramsay, as the Victorian man, "liked that men should labour and sweat on the windy beach at night; pitting muscle and brain against the waves and the wind; he liked men to work like that, and women to keep house, and sit beside sleeping children indoors, while men were drowned, out there in a storm" (TtL 245). Mr. Ramsay's view of the appropriate place for women is born of his belief in the limits of their intellect. "The vagueness of their minds is hopeless," he thinks; "[t]hey could not keep anything clearly fixed in their minds" (TtL 249). Yet he is rather fond of this very inadequacy, as he sees it. Watching his wife as she reads Shakespeare's sonnets, he "exaggerated her ignorance, her simplicity, for he liked to think that she was not clever, not book-learned at all. He wondered if she understood what she was reading. Probably not, he thought" (TtL 182). He is wrong. She understands very clearly what Shakespeare is saying, though not perhaps as he would understand it. But ignorance is built into his image of women, so his wife must lack understanding of Shakespeare.

If Mr. Ramsay embodies the Victorian male, Mrs. Ramsay is no less emblematic of the Victorian female; in fact at one of her most influential moments we see her standing "quite motionless for a moment against a picture of Queen Victoria wearing the blue ribbon of the Garter" (TtL 25). The Victorian woman, as Woolf saw her in her own mother, "delighted to transact all those trifling businesses which . . . are somehow derogatory to the dignity which they like to discover in clever men; and she took it as proud testimony that he [Sir Leslie]

came to her ignorant of all depressions and elations but those that high philosophy bred in him. But she never belittled her own works, thinking them, if properly discharged, of equal, though other, importance with her husband's" (MoB 37). Mrs. Ramsay goes a step further than her real-life model and is upset when people see that her husband depends on her, "[w]hen they must know that of the two he was infinitely the more important, and what she gave the world, in comparison with what he gave, negligible" (TtL 62). So throughout the novel she emphasizes "the greatness of man's intellect, even in its decay, the subjection of all wives" (TtL 20), and, unlike Mrs. Stephen, glories in mathematics at the dinner table, since it becomes symbolic of the supporting male: "she let it uphold her and sustain her, this admirable fabric of the masculine intelligence, which ran up and down, crossed this way and that, like iron girders spanning the swaying fabric, upholding the world" (TtL 159).

Masculine and feminine not only are different, in Victorian eyes, but demand very specific roles of men and women in the world. The man's intellect supports the woman. The woman, through marriage, serves the man.

In promoting her concept of the proper life for a woman, Julia Stephen tended to demand much of her daughters—Stella, Woolf's elder half-sister, in particular. "It was characteristic of her to feel that her daughter was, as she expressed it, part of herself, and . . . she did not scruple to treat her with the severity with which she would have treated her own failings, or to offer her up as freely as she would have offered herself" (MoB 42). Once she died, and Stella soon after her, the influence of this view rose up powerfully in the visions of her remaining daughters. "In our morbid state," Woolf wrote, "haunted by great ghosts, we insisted that to be like mother, or like Stella, was to achieve the height of human perfection" (MoB 53). There was much to recommend the propriety and service that characterized the life of the Victorian woman. Even at the time she was writing "A Sketch of the Past," Woolf confessed as much. "We still play the game," she wrote. "It is useful. It has also its beauty, for it is founded upon restraint, sympathy, unselfishness—all civilized qualities. It is helpful in making something seemly out of raw odds and ends" (MoB 150).

But although in some circumstances, and perhaps for some women, the old model might still work in the 1930s or 1940s, or even beyond, for the artist it offered a distinct disadvantage, for it interfered with the honesty and the courageous willingness to break through traditions that the artist must embrace in order to present the truth as she sees it. In "Professions for Women" Woolf confronts the caricature of the Victorian woman in a passage, which has become famous among her readers, that conceals behind the phantom it portrays recognizable aspects of both Mrs. Stephen and Mrs. Ramsay. "I discovered," she writes,

> that if I were going to review books I should need to do battle with a certain phantom. And the phantom was a woman, and when I came to know her better I called her after the heroine of a famous poem, The Angel in the House. It was she who used to come between me and my paper when I was writing reviews. It was she who bothered me and wasted my time and so tormented me that at last I killed her. You who come of a younger and happier generation may not have heard of her. . . . I will describe her as shortly as I can. She was intensely sympathetic. She was immensely charming. She was utterly unselfish. She excelled in the difficult arts of family life. She sacrificed herself daily. If there was chicken, she took the leg; if there was a draught she sat in it—in short she was so constituted that she never had a mind or a wish of her own, but preferred to sympathize always with the minds and wishes of others. . . . In those days—the last of Queen Victoria—every house had its Angel. And when I came to write I encountered her with the very first words. . . . Directly . . . I took my pen in my hand to review that novel by a famous man, she slipped behind me and whispered: "My dear, you are a young woman. You are writing about a book that has been written by a man. Be sympathetic; be tender. . . . Never let anybody guess that you have a mind of your own." . . . And she made as if to guide my pen. (CE 2:285)

So Woolf strangles her, an act of self-defense, saying, "Had I not killed her she would have killed me. She would have plucked the heart out of my writing."

A particular element, then, in the tension between the Victorian

and the Edwardian begins to emerge. The Victorian insists on mar-
riage as the end for woman, a marriage characterized by the woman's
giving up her own interests to serve her husband. Such a role makes
impossible any thought of her becoming a writer or any other sort of
professional artist, for art demands integrity; and self-sacrifice of the
Victorian sort is not often compatible with total honesty. Woolf
against her mother; Lily against Mrs. Ramsay; the Edwardian woman
against the Victorian; career against marriage. Here a theme within a
theme is set in motion, one that seems strangely contemporary even
now.

In *A Room of One's Own* Virginia Woolf spends some time ex-
amining the roles women have played in the past. For the most part,
she concludes, they "have served all these centuries as looking-glasses
possessing the magic and delicious power of reflecting the figure of
man at twice its natural size." And, she goes on, "[w]ithout that power
probably the earth would still be swamp and jungle" (ROO 35). It
may have been crucial to "all violent and heroic action" (ROO 36)
that men should be charged with vitality by seeing themselves as great
and powerful in comparison to the small figure of woman, whom they
had drawn as so clearly inferior to themselves. Yet there is no doubt
that women suffered, being squeezed into so small a space and being
kept from speaking their minds lest their outspoken views should
threaten the man's inflated self-image. "There was an enormous body
of masculine opinion," she writes, "to the effect that nothing could be
expected of women intellectually," and for women "there would al-
ways have been that assertion—you cannot do this, you are incapable
of doing that—to protest against, to overcome" (ROO 56), especially
for the painter, but also for the writer. "What genius," Woolf exclaims,
"what integrity it must have required in face of all that criticism, in
the midst of that purely patriarchal society, to hold fast to the thing as
they saw it without shrinking. Only Jane Austen did it and Emily
Brontë" (ROO 77–78). Others, like Charlotte Brontë, in the midst of
creating a work of art, would suddenly forget the essential objectivity
of that work and express their indignation at being so pinched and
pigeonholed by the masculine world, express themselves instead of

their characters, and so write books that were "deformed and twisted" (ROO 72). Perspective, detachment, are vital to the artist, and for the woman living with one foot in the Victorian past, with all the weight of a masculine history behind it, that detachment was very difficult to achieve.

Yet for Woolf, an interest in women is not merely directed at dispelling a Victorian stereotype and putting in its place a more three-dimensional modern woman who is free to be an artist. What she is looking toward is the discovery of the essentially feminine, in whatever age it appears; of a woman's art, whatever form it may take. So the possibility arises that Mrs. Ramsay may admire in Lily something unconfined by her Victorian notion of what a woman should be and that Lily may discover in Mrs. Ramsay (as Woolf in her mother) an element of the feminine not inconsistent with art. For women are complicated beings, still undefined when the calendar flipped its pages from 1860 to 1910. "There is no mark on the wall to measure the precise height of women," Woolf wrote in *A Room of One's Own*. "There are no yard measures, neatly divided into the fractions of an inch" (ROO 89). Something about woman makes her very difficult to pin down. Woolf is eager to see some writer "catch those unrecorded gestures, those unsaid or half-said words, which form themselves, no more palpably than the shadows of moths on the ceiling, when women are alone" (ROO 88).

One of the problems with catching woman in the net of definition that novelists have used successfully for man is that women live their lives differently from men, inhabit, as Woolf notes both for women like her mother and for Mrs. Ramsay, the ephemeral. "Often nothing tangible remains of a woman's day. The food that has been cooked is eaten; the children that have been nursed have gone out into the world. Where does the accent fall? What is the salient point for the novelist to seize upon? It is difficult to say. Her life has an anonymous character which is baffling and puzzling in the extreme" (CE 2:146). What makes the challenge particularly great for the novelist in Woolf's day is that just as "the dark country" of woman's life "is beginning to be explored in fiction," women are changing, entering the professions,

coming to the surface of the outer world. In all the ages before Woolf's own, women had lived in an interior world, had been defined by and had defined the rooms they inhabited, the homes they made. This interior world gradually became saturated with the essence of the feminine so that "the resources of the English language would be much put to the stretch, and whole flights of words would need to wing their way illegitimately into existence before a woman could say what happens when she goes into a room" (ROO 91), a room that has grown to represent the life of womankind, as Woolf puts it in *A Room of One's Own:* "one has only to go into any room in any street for the whole of that extremely complex force of femininity to fly in one's face. How should it be otherwise? For women have sat indoors all these millions of years, so that by this time the very walls are permeated by their creative force, which has, indeed, so overcharged the capacity of bricks and mortar that it must needs harness itself to pens and brushes and business and politics" (ROO 91).

Mrs. Ramsay, who embodies this anonymous, dark life of women, almost never leaves the house in the hours during which *To the Lighthouse* takes place (although we are allowed to picture her on earlier ventures into town). She may long to run down to the beach with the younger generation once dinner is over but cannot, for she is carrying with her that aspect of the feminine that enacts its magic within doors. And magic, creative magic, it is. For if women have served as fun-house mirrors for men throughout history, they have also offered something far more important and valuable to the men who entered their enchanted rooms. What such men got, Woolf says, "was something that their own sex was unable to supply . . . some stimulus, some renewal of creative power which is in the gift only of the opposite sex to bestow." She goes on:

> He would open the door of drawing-room or nursery, I thought, and find her among her children perhaps, or with a piece of embroidery on her knee—at any rate, the centre of some different order and system of life, and the contrast between this world and his own, which might be the law courts or the House of Commons,

would at once refresh and invigorate; and there would follow, even in the simplest talk, such a natural difference of opinion that the dried ideas in him would be fertilized anew; and the sight of her creating in a different medium from his own would so quicken his creative power that insensibly his sterile mind would begin to plot again, and he would find the phrase or the scene which was lacking when he put on his hat to visit her. (ROO 90)

So Mrs. Ramsay serves her husband in a scene that contains much of the same language Woolf uses here. Mr. Ramsay comes to her "to be taken within the circle of life, warmed and soothed, to have his senses restored to him, his barrenness made fertile, and all the rooms of the house made full of life" (TtL 59). "Flashing her needles," with her son on her lap, like the woman among her children and embroideries that Woolf describes above, she "created drawing-room and kitchen, set them all aglow; bade him take his ease there" (TtL 59); and he, at such moments, "fortified" and "satisfied," can then consecrate "his effort to arrive at a perfectly clear understanding of the problem which now engaged the energies of his splendid mind" (TtL 53).

The creative power of the male is enabled by the creative power of the female. And such an interaction of different aspects of creativity leads Woolf to see more clearly the existence of complementary but separate characteristics of the sexes. The creativity that women had for generations injected into their homes and that, in Woolf's day, was spilling out into the professions "differs greatly from the creative power of men. And one must conclude," she goes on to say, "that it would be a thousand pities if it were hindered or wasted, for it was won by centuries of the most drastic discipline, and there is nothing to take its place. It would be a thousand pities if women wrote like men, or lived like men, or looked like men, for if two sexes are quite inadequate, considering the vastness and variety of the world, how should we manage with one?" (ROO 91).

If the masculine and the feminine are both vital forms of creativity in the world, one might begin to suspect that for the total artist some combination of both forms would lead to the richest art, not a combination in which one form would be engulfed by the other, but a

combination that would stand as a marriage of the two. In fact marriage of the male and female, both literal and figurative, provides a source of wholeness in much of Woolf's thinking. "One has a profound, if irrational, instinct," she says, "in favour of the theory that the union of man and woman makes for the greatest satisfaction, the most complete happiness. But the sight of the two people getting into the taxi," she goes on to say, commenting on the scene that provoked her thought, "and the satisfaction it gave me made me also ask whether there are two sexes in the mind corresponding to the two sexes in the body, and whether they also require to be united in order to get complete satisfaction and happiness" (ROO 101–2). So she concludes, going on to speculate that such a union is what Coleridge meant when he spoke of the androgynous mind that is "naturally creative, incandescent and undivided" (ROO 102). "Incandescent" is the adjective Woolf chooses to describe the mind of Shakespeare (ROO 54), which she offers as "the type of the androgynous" (ROO 102). "It is fatal for anyone who writes to think of their sex," she says; "one must be woman-manly or man-womanly" (ROO 108) like Shakespeare, or Jane Austen, having "consumed all impediments" (ROO 71). So a woman who is an artist, writing in the twentieth century, must be able to absorb Mrs. Ramsay's sort of creativity and Mr. Ramsay's. The feminine embodied in the Victorian woman cannot be lost but must be transformed in a union with the masculine. And the possibility that Mrs. Ramsay herself might see and appreciate such a union becomes clear when we perceive her holding the "essence sucked out of life" in the form of the sonnet of Shakespeare that rests in the cup of her hands.

Thus Virginia Woolf, in freeing herself from her obsession with her mother and placing Julia Stephen as the representative of the Victorian woman, is not casting off the past but reclaiming it through perspective. "We think back through our mothers if we are women" (ROO 79), she says, and not just our literary mothers but our literal ones.[25] In fact the novelist in particular can lay claim to the sort of creativity exemplified by Mrs. Stephen, for the sensibilities of women like her "had been educated for centuries by the influences of the

common sitting-room. People's feelings were impressed on her; personal relations were always before her eyes" (ROO 70). What else forms the basis of fiction, which is defined by the creation of character?

Yet it is no accident that Mrs. Ramsay, in preparation for her being carried over into Lily Briscoe's modern world in a purified form, is reading Shakespeare's poetry and not the novels of Austen. For it is poetry that Woolf sees as necessary to the modern, female artist. "The greater impersonality of women's lives," she speculates, looking into the future, "will encourage the poetic spirit, and it is in poetry that women's fiction is still weakest. It will lead them to be less absorbed in facts and no longer content to record with astonishing acuteness the minute details which fall under their own observation. They will look beyond the personal and political relationships to the wider questions which the poet tries to solve—of our destiny and the meaning of life" (CE 2:147).

Woolf's personal life is at the heart of *To the Lighthouse*. And in her examination of the tension between the Victorian world and the modern she wrestles with the political as well. But it is in her quest for poetry and her attempt to answer our questions about the meaning of life that her novel grows deepest and widest. *To the Lighthouse*, in stretching toward the poetic and the universal, assumes a form not found in works that preceded it. We might understand it as a book that has somehow been "adapted to the body" of the woman, "shorter, more concentrated, than [that] of men" (ROO 81). To create such a work, feminine in form yet androgynous in its totality, was no easy matter in her day, when women were changing while masculine ideas about woman were still stuck in the past. But a new sort of art is what this novel aims at, one that includes the past without being dominated by it, that escapes the limits of male or female to present something incandescent and whole. And the examination of art itself was, for Woolf, part of the process of achieving the poetic spirit that she looked for in the modern novel.

– 8

TO THE LIGHTHOUSE
Bloomsbury Art Theory
and Woolf's Concept of Art

When Lily Briscoe sets up her easel on the Ramsays' lawn and faces a blank canvas onto which she must transfer her vision of what is before her, arranged to express an elusive answer to "a simple question," "What is the meaning of life?" (TtL 240), she makes explicit an issue that is implicit in most of the novel. For *To the Lighthouse* is among other things a novel about art, what it aims for, what it might achieve, and what means it should employ to reach its end. These questions about art are presumably hovering in the lives of all serious writers; but for Virginia Woolf art theory was as much in the air as cigarette smoke during the many evenings when she would sit talking with her sister and her friends. Vanessa was a painter, married to Clive Bell, whose cocky little book on art had caused much talk in its day. When Clive moved to the outskirts of her life, Roger Fry, for a time, moved to the center, becoming so important a part of Virginia's life as well that it was she who was asked to write his biography after he died. In his day, Roger Fry was one of his country's most influential art critics. His organizing of the First Post-Impressionist Exhibition in November 1910 shook accepted notions of art and his lectures converted many to his views. Virginia Woolf, too, found that his ideas soon captured her imagination.

"Why is it," she asks in her biography of Fry, "that Roger Fry's criticism has for the common seer something of the enthralment of a novel, something of the excitement of a detective story while it is strictly about the art of painting and nothing else?"[26] The easiest answer to her question is to offer another quotation, one from Fry's *Vision and Design,* published just five years before Woolf began *To the Lighthouse.* Woolf chose this passage as one to cite in her biography, perhaps because it centers on a particular concept of reality that surfaces in her own writing like a leitmotif. In it, Fry is attempting to explain to his audience the aims of Cézanne and the other postimpressionists:

> Now, these artists do not seek to give what can, after all, be but a pale reflex of actual appearances, but to arouse the conviction of a new and definite reality. They do not seek to imitate form, but to create form; not to imitate life, but to find an equivalent for life. By that I mean that they wish to make images which by the clearness of their logical structure, and by their closely-knit unity of texture, shall appeal to our disinterested and contemplative imagination with something of the same vividness as the things of actual life appeal to our practical activities. In fact, they aim not at illusion but at reality. (V&D 239)

In order to understand the postimpressionists' effort to crystallize reality, at least as Woolf saw it, it is necessary to explore Fry's theories more carefully. In them we shall discover much that makes him kin to Lily Briscoe and that helps us understand Virginia Woolf's own attempt in her novel to make life stand still. To begin with, Fry was much concerned with the relationship between art and life. "The usual assumption of direct and decisive connection between life and art," he writes, "is by no means correct." For art is separated from life, self-contained, shaped more "by its own internal forces—and by the re-adjustment within it, of its own elements—than by external forces" (V&D 9). Whereas actual life demands responsive action, the writing of a check or the joining of a society, art requires "no such moral responsibility—it presents a life freed from the binding necessities of

our actual existence" (V&D 21). Morality values emotion as an impetus to action. "Art appreciates emotion in and for itself" (V&D 27). Yet art has its own morality, as Clive Bell argued and as Fry would agree, for "works of art are immediate means to good."[27] Thus art is defined by the arrangement of its own elements yet conveys particular emotions that present the viewer with "a new and definite reality." In fact the title of Fry's most important collection of essays, "Vision and Design," sums up quite neatly the double emphasis of his theory and sets up a dualism similar to that which Virginia Woolf found present wherever she looked.

One of the elements of postimpressionist art that Fry found most exciting but that gave the most trouble to the viewing public in his day was that it de-emphasized the representational aspect of painting. This movement away from art as imitation was announced by Clive Bell with his typical bravado: "the representative element in a work of art may or may not be harmful; always it is irrelevant. For, to appreciate a work of art we need bring with us nothing from life, no knowledge of its ideas and affairs, no familiarity with its emotions. Art transports us from the world of man's activity to a world of aesthetic exaltation."[28] In more measured terms, Fry faults the impressionists for carrying the pursuit of imitation so far that they "reduced the artistic vision to a continuous patchwork or mosaic of coloured patches without architectural framework or structural coherence," pushing representation as far as it could go. At this point, he goes on to say, "it was inevitable that artists should turn round and question the validity of the fundamental assumption that art aimed at representation; and the moment the question was fairly posed it became clear that the pseudo-scientific assumption that fidelity to appearance was the measure of art had no logical foundation" (V&D 11). The postimpressionists, in contrast to their predecessors, then, established "purely aesthetic criteria in place of the criterion of conformity to appearance" and advocated "the principles of structural design and harmony" (V&D 12). Fry realized that this emphasis on design would make new demands on the public. "In proportion as art becomes purer," he writes, "the number of people to whom it appeals gets less. It cuts out

all the romantic overtones of life which are the usual bait by which men are induced to accept a work of art. It appeals only to the aesthetic sensibility, and that in most men is comparatively weak" (V&D 15). So, like the modern writer, the modern painter was venturing into new territory, the old having been farmed to death; but those who followed might be few.

If representation is no longer central, what must artists pursue with their newly established emphasis on design if they are to create satisfying works of art? Fry answers the question in a way that finds an echo in Woolf's novel:

> One chief aspect of order in a work of art is unity; unity of some kind is necessary for our restful contemplation of the work of art as a whole, since if it lacks unity we cannot contemplate it in its entirety, but we shall pass outside it to other things necessary to complete its unity.
>
> In a picture this unity is due to a balancing of the attractions of the eye about the central line of the picture. (V&D 31)

And here is Lily Briscoe, reaching for detachment as she, too, searches for unity in her picture:

> She took up once more her old painting position with the dim eyes and the absent-minded manner, subduing all her impressions as a woman to something much more general; becoming once more under the power of that vision which she had seen clearly once and must now grope for among hedges and houses and mothers and children—her picture. It was a question, she remembered, how to connect this mass on the right hand with that on the left. She might do it by bringing the line of the branch across so; or break the vacancy in the foreground by an object (James perhaps) so. But the danger was that by doing that the unity of the whole might be broken. (TtL 82–83)

So Lily, attempting to leave her awareness of her own sex and become something nonsexual, as Woolf has made clear must be the stance of the successful artist, sets about balancing the elements of her painting

and achieving the unity that Fry describes. In the process, trees, houses, people lose their representational force and become mere objects to be arranged within the space of the canvas.

This balancing of masses, this arrangement of objects, that makes up a unified picture is, according to Fry, achieved by several qualities of line: first, rhythm, "our sense of sight being constructed like our sense of sound, so that certain relations, probably those which are capable of mathematical analysis, are pleasing, and others discordant. Secondly, the significance of line as enabling us imaginatively to reconstruct a real, not necessarily an actual, object from it. The greatest excellence of this quality," he goes on to say, "will be the condensation of the greatest possible suggestion of real form into the simplest, most easily apprehended line; the absence of confusing superfluity on the one hand, and mechanical, and therefore meaningless simplicity, on the other" (V&D 175). This latter element (and Lily and Woolf, as we shall see, emphasize the former as well) is achieved by Lily in her careful placing in her painting of that triangular purple shape that puzzles Mr. Bankes. When he asks her about it she answers: "It was Mrs. Ramsay reading to James. . . . She knew his objection—that no one could tell it for a human shape. But she had made no attempt at likeness, she said. For what reason had she introduced them then? he asked. Why indeed?—except that if there, in that corner, it was bright, here, in this, she felt the need of darkness" (TtL 81). Lily may disclaim any attempt to suggest a human form by her purple triangle, but when we discover that Mrs. Ramsay sees herself in these same geometric terms, as a "wedge-shaped core of darkness" (TtL 95), we realize that Woolf has equipped her own artist with just the qualities Fry would applaud. Lily may not be portraying the actual Mrs. Ramsay, but she is offering the "real" one, in that italicized term Woolf and Fry both use so reverently.

If suggestive form is a part of the balanced whole, so are other elements that Fry lists and Woolf includes in her depiction of Lily's work: mass, space, light and shade, color, and, once again, rhythm (V&D 33–34). We have already noted that Woolf saw rhythm as an element necessary to style, a force that lay deeper than words and

extended beyond them to move the writer's vision onto the page.[29] When Lily finally begins what will become her completed picture, it is rhythm that drives her: "And so pausing and so flickering, she attained a dancing rhythmical movement, as if the pauses were one part of the rhythm and the strokes another, and all were related; and so, lightly and swiftly pausing, striking, she scored her canvas with brown running nervous lines which had no sooner settled there than they enclosed (she felt it looming out at her) a space" (TtL 235–36).

Fry's criticism emphasizes these formal elements of design, but he, like Woolf, is quick to admit that "in our reaction to a work of art there is something more—there is the consciousness of purpose, the consciousness of a peculiar relation of sympathy with the man who made this thing in order to arouse precisely the sensations we experience" (V&D 30). Although detachment is part of the artist's stance and ought to be part of the viewer's—a detachment that can create and appreciate order and balance—there is, also, a genuine and strong emotion that passes from artist to viewer through the picture, an emotion that conveys the artist's main idea, his or her vision (V&D 294). There is no doubt that the artist, in apprehending and passing on this vision, requires quite extraordinary discipline and honesty. Writing of El Greco, whom he admired for just these qualities, Fry argues that "he was a singularly pure artist, he expressed his idea with perfect sincerity, with complete indifference to what effect the right expression might have on the public. At no point is there the slightest compromise with the world; the only issue for him is between him and his idea. Nowhere is a violent form softened, nowhere is the expressive quality of brushwork blurred in order to give verisimilitude of texture; no harshness of accent is shirked, no crudity of colour opposition avoided, wherever El Greco felt such things to be necessary to the realisation of his idea" (V&D 210). Lily Briscoe, aiming for this same purity, feels herself struggling against the world in order "to maintain her courage; to say: 'But this is what I see'" (TtL 32); and what she sees Woolf may have allowed her to see under the influence of Fry's essay on El Greco. For the softening of form, the gentling of color is just what Mr. Paunceforte and his school, those traditional painters

who come to the Ramsays' beach to work, are requiring of the artist. Yet Lily sees "[t]he jacmanna was bright violet; the wall staring white. She would not have considered it honest to tamper with the bright violet and the staring white, since she saw them like that, fashionable though it was, since Mr. Paunceforte's visit, to see everything pale, elegant, semitransparent" (TtL 31–32). Lily has her vision, one that includes "crudity of colour opposition," and it is interesting that Mrs. Ramsay seems to share Lily's perception, since she, too, suggests that Mr. Paunceforte's "colours weren't solid" (TtL 24). The creative force is meant to convey the truth as the artist understands it. Mass, space, rhythm, color, line, the balance of elements around a central line are not ends in themselves, for form is not mere form when it makes up a work of art. It is what Clive Bell termed "significant form."[30]

"Form" puts its emphasis on the element of design in a work; "significant" emphasizes the vision. Significant form expresses an idea, and not merely a pleasing object. It is the form that is inherent in great art, and for Fry "it implies the effort on the part of the artist to bend to our emotional understanding by means of his passionate conviction some intractable material which is alien to our spirit" (V&D 302). Once the artist has succeeded in conveying this passionate vision through significant form, "[w]e feel that he has expressed something which was latent in us all the time, but which we never realised, that he has revealed us to ourselves in revealing himself" (V&D 30), so that something universal emerges in the act of communication. At its most successful, art moves into the realm of the religious, the eternal. "As I understand it," says Fry, "art is one of the chief organs of what, for want of a better word, I must call the spiritual life. It both stimulates and controls those indefinable overtones of the material life of man which all of us at moments feel to have a quality of permanence and reality that does not belong to the rest of our experience" (V&D 55). Lily and Mr. Carmichael agree, feeling that though "'you' and 'I' and 'she' pass and vanish," in words and paint what is attempted "remained for ever" (TtL 267). Bell finds in art "that which philosophers used to call 'the thing in itself' and now call 'ultimate reality'" and argues that art, like religion, "is an expression of the

individual's sense of the emotional significance of the universe."[31] The last lines of *Vision and Design,* which Woolf quoted in her biography of Fry, bring us closest to understanding the possibilities inherent in the aesthetic emotion conveyed by art as Fry saw it: "One can only say that those who experience it feel it to have a peculiar quality of 'reality' which makes it a matter of infinite importance in their lives. Any attempt I might make to explain this would probably land me in the depths of mysticism. On the edge of that gulf I stop" (V&D 302).

Roger Fry, in presenting art as an organ of the spiritual life that could awaken in the viewer a perception of ultimate reality, was speaking, as Woolf points out in her biography, strictly about painting, and his theories translate most easily into Woolf's own art in the figure of Lily Briscoe, who shares Fry's vision and relies, as he did, on brushes and a palette to convey it. But neither vision nor design is restricted, even in his eyes, to a single form of art, and he makes clear that "the purpose of literature [as of painting] is the creation of structures which have for us the feeling of reality, and that these structures are self-contained, self-sufficing, and not to be valued by their references to what lies outside."[32] Woolf found this self-contained quality (she uses the same term as Fry) in the fiction of Austen and Sterne, but for Fry, literature seldom met the strict requirements for pure art. "Even in the novel," he writes, "which as a rule has pretensions to being a work of art, the structure may be so loose, the esthetic effects may be produced by so vast an accumulation of items that the temptation for the artist to turn aside from his purpose and interpolate criticisms of life, of manners or morals, is very strong. Comparatively few novelists have ever conceived of the novel as a single perfectly organic esthetic whole."[33] If Fry raised some doubts about the true artistry of the novel, Bell, like Charles Tansley, was quick with his absolutes, saying: "Literature is never pure art."[34] Even in poetry, he says, "the form and the content are not one. . . . The form is burdened with an intellectual content, and that content is a mood that mingles with and reposes on the emotions of life. That is why poetry, though it has its raptures, does not transport us to that remote aesthetic beatitude in which, freed from humanity, we are upstayed by musical and pure visual form."[35]

So Virginia Woolf faced a formidable challenge in attempting to create a novel that was a work of art, surrounded as she was by men of such firm opinion, whose theories she both admired and, in good part, shared. Yet it is clear that she saw in the best literature just those elements of purified reality, set beyond the limits of mere representation, that Fry and Bell found in the best paintings. "A power which is not the power of accuracy or of humour or of pathos is also used by the great novelists to shape their work," she writes. "As the pages are turned, something is built up which is not the story itself" (CE 2:101). Often in describing a novel she uses terms that Fry might have used in his art criticism, terms suggesting mass, space, and line. For example, a novel, she says, "is a structure leaving a shape on the mind's eye, built now in squares, now pagoda shaped, now throwing out wings and arcades, now solidly compact and domed like the Cathedral of Saint Sofia at Constantinople. This shape, I thought, thinking back over certain famous novels, starts in one the kind of emotion that is appropriate to it. But that emotion at once blends itself with others, for the 'shape' is not made by the relation of stone to stone, but by the relation of human being to human being" (ROO 74). Like Fry's pure art, the novel is composed of a balance of forms that evoke an appropriate response in the viewer. By form she means "that certain emotions have been placed in the right relations to each other" (CE 2:129). Aspects of life, human beings and the emotions they evoke or convey, make up the significant form of the novel so that it can express a reality not foreign to that experienced by the reader but familiar, calling up sensations that suggest that life itself can be seen as a work of art, an idea that goes beyond Fry's concept of the separation of art and life without destroying the belief that art should be self-sufficient.

Life and art, vision and design: throughout the writing of both Fry and Woolf we find the introduction of pairs of qualities, sometimes apparently opposites, that need to be brought into balance before unity can be achieved. As Woolf puts it in summing up Fry's theories, "while every sensation was to be savoured, and none rejected off-hand, a balance seemed to have been arrived at—a balance between the emotions and the intellect, between Vision and Design."[36]

"Intellect" and "emotion" may or may not embrace the idea behind Fry's terms, but they capture his theories as Woolf understood them and became important in defining those opposites that Woolf attempted to unite in *To the Lighthouse*—Mr. and Mrs. Ramsay. So, too, when she brought all her talents to bear on the achieving of that unity in her novel, she wrote to Fry, describing her attempt, in terms that echo his own insistence that "in a picture this unity is due to a balancing of the attractions of the eye about the central line of the picture" (V&D 31), in this case the image of the lighthouse: "I meant *nothing* by The Lighthouse. One has to have a central line down the middle of the book to hold the design together. I saw that all sorts of feelings would accrue to this, but I refused to think them out, and trusted that people would make it the deposit for their own emotions—which they have done, one thinking it means one thing another another. I can't imagine Symbolism except in this vague generalised way."[37]

A line down the center, uniting the whole. Literature can achieve this as well as painting. And literature, like painting, goes in pursuit of reality in its purest form. "The greatest book in the world," according to Woolf, "would be that . . . made solely & with integrity of one's thoughts. Suppose one could catch them before they became 'works of art'?"[38] So Lily wishes, in Bell's own terms, "to get hold of . . . that very jar on the nerves, the thing itself before it has been made anything" (TtL 287). But the painter has an edge over the writer, for he or she works with shapes and colors that are freed from any preordained meanings and the writer must use words, words that often get in the way of the thing itself.[39] If words do generally bring the representational world with them and so interfere with the achievement of pure art, even they, at times, can throw a net over reality and express what lies dormant in the mind of the reader. Woolf experienced this power of words herself one afternoon as she sat in the park, shortly after her mother's death, reading a poem. Suddenly, "[i]t was as if it became altogether intelligible; I had a feeling of transparency in words when they cease to be words and become so intensified that one seems to experience them; to foretell them as if they developed what one is

already feeling" (MoB 93). She discovered in the poem that successful art Fry described, art that expresses "something which was latent in us all the time" (V&D 30) and so captures "reality."

One thing further is needed before we can enter the self-contained world of *To the Lighthouse* and discover the ways that it shapes the masses that comprise it into a work of art, balanced, carefully designed, conveying Woolf's vision: and that is to understand a little more of what that vision, Woolf's philosophy of life, as she puts it, actually was. It is not until "A Sketch of the Past," composed between 1939 and 1940, that she discusses it overtly, but in her draft of *To the Lighthouse* she was already presenting it in phrases that are remarkably like those she uses in her late memoir.

Two terms emerge in "A Sketch of the Past" that describe two very different and important aspects of life for Woolf: *non-being* and *being*. *Non-being* is the unconscious, quickly forgotten daily routine, the unmemorable meals, rambling thoughts, automatic conversation that gets us from waking in the morning to falling asleep at night. *Being* is something luminous, shocking, alive, that stands out in the nonbeing that surrounds it, a "goodness" that is "embedded in a kind of nondescript cotton wool" (MoB 70) that makes up most of the day. In attempting to clarify her concept of nonbeing and being, Woolf returns to her childhood at St. Ives, saying: "my days, just as they do now, contained a large proportion of this cotton-wool, this non-being. . . . Then, for no reason that I know about, there was a sudden violent shock; something happened so violently that I have remembered it all my life" (MoB 71). For examples, she chooses three, two frightening and one illuminating. In the first, during a fistfight with Thoby, she suddenly was overcome with sadness and stood letting him pommel her. In the second she learned that an adult acquaintance had killed himself (MoB 71). In the third, she writes: "I was looking at the flower bed by the front door; 'That is the whole,' I said. I was looking at a plant with a spread of leaves; and it seemed suddenly plain that the flower itself was a part of the earth; that a ring enclosed what was the flower; and that was the real flower; part earth; part flower" (MoB 71). Thinking back on these three moments of being, she

realizes that only the third resulted in a state of satisfaction and finds that this satisfaction arose from her having been able to understand the flower, see a reason behind it, and so gain a power over the sensation it gave her. She continues her musing:

> [S]o I go on to suppose that the shock-receiving capacity is what makes me a writer. I hazard the explanation that a shock is at once in my case followed by the desire to explain it. I feel that I have had a blow, but it is not, as I thought as a child, simply a blow from an enemy hidden behind the cotton wool of daily life; it is or will become a revelation of some order; it is a token of some real thing behind appearances; and I make it real by putting it into words. It is only by putting it into words that I make it whole; this wholeness means that it has lost its power to hurt me; it gives me, perhaps because by doing so I take away the pain, a great delight to put the severed parts together. (MoB 72)

This suggestive passage offers a glimpse of the process through which Virginia Woolf discovered some order behind the pattern of shocks that marred her childhood—the deaths of her mother, her half-sister, her brother; the horror of the war—by putting them into words in *To the Lighthouse* and so overcoming the pain they had caused her. It also gives a hint that Woolf perceives some absolute reality behind appearances in life, a reality that can be "realized" in the sort of incarnation that is available to the artist through words.

In *A Room of One's Own* she explores this concept of reality (one that is first cousin if not an identical twin to that offered us by Fry and Bell) in some detail. "What is meant by 'reality'?" she asks.

> It would seem to be something very erratic, very undependable— now to be found in a dusty road, now in a scrap of newspaper in the street, now in a daffodil in the sun. It lights up a group in a room and stamps some casual saying. It overwhelms one walking home beneath the stars and makes the silent world more real than the world of speech—and then there it is again in an omnibus in the uproar of Piccadilly. Sometimes, too, it seems to dwell in shapes too far away for us to discern what their nature is. But whatever it

touches, it fixes and makes permanent. . . . Now the writer, as I think, has the chance to live more than other people in the presence of this reality. It is his business to find it and collect it and communicate it to the rest of us. (ROO 113–14)

So the writer must gather up and arrange these glimpses of permanence, which might go unnoticed were he, or she, not there to reveal a larger unity through creating the finite unity of the work of art. Like Fry (and with many of the same assumptions) Woolf stands at the edge of the mystical.

Some might argue that she dares to step over this edge when she offers, again in "A Sketch of the Past," what she calls "a philosophy": "that behind the cotton wool is hidden a pattern; that we—I mean all human beings—are connected with this; that the whole world is a work of art; that we are parts of the work of art. *Hamlet* or a Beethoven quartet is the truth about this vast mass that we call the world. But there is no Shakespeare, there is no Beethoven; certainly and emphatically there is no God; we are the words; we are the music; we are the thing itself. And I see this when I have a shock" (MoB 72). Suddenly the careful line drawn by Fry between life and art, a line that allows us to feel aesthetic emotion when looking at a painting but rarely when examining a flower or standing before a sunset, suddenly this line has vanished. The "ultimate reality," "the thing itself," which great art alone, according to Fry, is able to offer, is present in life itself, if only we have the understanding to see it. There is present here the suggestion that the artist is most open to this understanding, most able to discover it for the rest of us, but what the artist reveals is not just a private idea or opinion, but truth itself, "the meaning of life."

In her draft of *To the Lighthouse,* Woolf roughed out two passages that, though absent in the final version, show that this sense of a hidden, ultimate pattern, revealed by the artist but present in all life, making that life a work of art, was very much on her mind as she wrote. In the first, Lily sits sketching "as if all were ordered & appointed; as if . . . human life too were susceptible, like a picture, to . . . arrangement & order" (TtLd 260; ellipses represent

crossed-out phrases). And in the second she thinks back to the afternoon when Mrs. Ramsay created a moment that made life stand still: "There was one of those moments. And it could be held in the fingers, looked up & round; & never lost its endlessness. . . . Threw out like radium its . . . meaning. . . . By this means . . . as . . . people said, possibly one might in the course of time work ones [*sic*] way to a system, philosophy, or understanding of life: the first step being that she at the age of forty four, grasped . . . hold of the fact that there was an order, a succession of stepping stones, or, did one choose to put it so, of flowers . . . perfectly composed" (TtLd 294). So life is not chaotic, threatening, destructive, but ordered and whole, if only we can see it. If we can uncover the pattern, reveal the balance that keeps all oppositions in equilibrium, we shall see what the artist sees, and what is really there: the fact that life is a work of art.

— 9 ─────────────

TO THE LIGHTHOUSE
The Thing Itself

A successful novel, according to Virginia Woolf, must be self-contained, must so present the material within it that we can hold it in our hands, "beautiful and reasonable, clear and complete, the essence sucked out of life and held rounded here" (TtL 181). The time has now come for us to see how *To the Lighthouse* creates such a single, united shape out of its disparate parts to become one of those globed, compacted things that reveal some permanence behind appearances. The problem it confronts is set most neatly before us in a fragment from the draft: "How should one & link up bridge the connect the two chief blocks of matter so that must somehow be joined together" (TtLd 93). Woolf gropes for the accurate phrase (enacting an effort that Lily will duplicate in the novel itself) but her goal is clear—to reveal the order hidden behind the daily blur, to bring together through some delicate arrangements, some central line, the opposing aspects of life, variously defined as we have seen—the past and the present, the Victorian views of women and the modern, the male and the female, art and life—and to unite them both within human relationships and within individual persons. But how, in a work of art that aims at universals, at some sort of ultimate reality, how to present

these blocks? And how to show the forces at work that might bring opposites into harmony and make, or reveal, a unity in life?

One answer, painted in broad strokes (the details will be added later) is found in the tripartite structure of the novel. The first section, "The Window," sets forth the painter's problem, defines the blocks of matter to be joined, and offers hints of the solutions to come. Next comes the impersonal world of "Time Passes," the dividing line between past and future, which suggests both a breaking of the order glimpsed in the first section and, paradoxically, the central line that brings all around it into unity. Finally, we reach "The Lighthouse," the place where potential solutions are actualized, the painting completed. So the three parts define and resolve the problem in setting the first and last sections against one another with the central section as fulcrum until the whole novel hangs in equilibrium before us like perfectly balanced scales, whole, entire, self-contained.

"The Window"

From the very outset of the novel the problem of unresolved discord is offered to us most directly in the figures of Mr. and Mrs. Ramsay, who, with their "yes" and their "but," represent two different attitudes toward life's possibilities. The two are part of one whole, as the continuing emphasis on their marriage makes plain, but their separateness is what is initially most firmly set before us, and only gradually do we realize the underlying fact of their connection.

Mr. Ramsay is, superficially, the figure of the Victorian paterfamilias, authoritarian, detached emotionally from his family, asserting his male superiority as he pursues his concept of truth with integrity but insensitivity. Yet we soon are allowed to discover that he also represents some essential and admirable quality of the human mind that it is easiest, given Woolf's goal of androgyny, to call the masculine. Lily Briscoe, the artist in the novel, looks for a definition of Mr. Ramsay's approach to life and begins by asking about his books, What were they about? "'Subject and object and the nature of reality,' Andrew

had said. And when she said Heavens, she had no notion what that meant. 'Think of a kitchen table then,' he told her, 'when you're not there'" (TtL 38). Mr. Ramsay seeks to perceive reality purely intellectually, to remove all that coloring of the subjective that would keep any group of people, however equally gifted artistically, from painting the same picture when rendering their vision of a given table. Any elements of life that would add a personal, interpretive tone to what is observed must therefore be set aside—all emotion, aesthetic judgment, assigning of value—and the man (for it would be a man) who attempts such a pure vision stands apart from the world, as Lily sees: "Naturally, if one's days were passed in this seeing of angular essences, this reducing of lovely evenings, with all their flamingo clouds and blue and silver to a white deal four-legged table (and it was a mark of the finest minds so to do), naturally one could not be judged like an ordinary person" (TtL 38). Beauty is one of those aspects of life that Mr. Ramsay cannot contain within the net of the rational that he uses to capture the truth. It escapes definition, evokes emotion, and has a luminous power that cannot be described mathematically. So although his understanding often astonishes his wife, she sees that he never notices the sunsets, the flowers; even his daughter's beauty evades him. When he is pursuing truth with as much integrity as he possesses, all these lovely intrusions must be sacrificed so that he can stand firmly on what can be objectively known. Woolf presents this intellectual gift of his in such a way that we can see in it Mr. Ramsay's essential self:

> It was his fate, his peculiarity, whether he wished it or not, to come out thus on a spit of land which the sea is slowly eating away, and there to stand, like a desolate sea-bird, alone. It was his power, his gift, suddenly to shed all superfluities, to shrink and diminish so that he looked barer and felt sparer, even physically, yet lost none of his intensity of mind, and so to stand on his little ledge facing the dark of human ignorance, how we know nothing and the sea eats away the ground we stand on—that was his fate, his gift. But having thrown away, when he dismounted, all gestures and fripperies, all trophies of nuts and roses, and shrunk so that not only fame but even his own name was forgotten by him, he kept even in that

desolation a vigilance which spared no phantom and luxuriated in no vision, and it was in this guise that he inspired in William Bankes (intermittently) and in Charles Tansley (obsequiously) and in his wife now, when she looked up and saw him standing at the edge of the lawn, profoundly, reverence, and pity, and gratitude too, as a stake driven into the bed of a channel upon which the gulls perch and the waves beat inspires in merry boat-loads a feeling of gratitude for the duty it is taking upon itself of marking the channel out there in the floods alone. (TtL 68–69)

Like the solid tower of the Lighthouse seen by day, with its clear-cut bars of black and white, Mr. Ramsay at his purest stands bravely on the little rock of human knowledge, limited though it is, and gives the rest of life's wayfarers, who may be venturing forth on the wider but more dangerous path of the sea, something to rely on.

For all the value of Mr. Ramsay's solid island of objective truth, there is a suspicion even in his own mind that he has not quite got all of life under his feet. When he attempts to define his own intellectual goal, the reaching of Z in the alphabet of knowledge, he realizes that he has reached only Q and that his method of moving from letter to letter, even if he should manage to get through all twenty-six, is in its way limited: "he could see, without wishing it, that old, that obvious distinction between the two classes of men; on the one hand the steady goers of super-human strength who, plodding and persevering, repeat the whole alphabet in order, twenty-six letters in all, from start to finish; on the other the gifted, the inspired who, miraculously, lump all the letters together in one flash—the way of genius" (TtL 55). Mr. Ramsay is a plodder, courageous and persevering though he may be. The ability to see all life in a flash is beyond him.

Mrs. Ramsay, his opposite, is, like her husband, superficially the representative of the Victorian, a woman who leaves thinking to the men and devotes herself to her children and to the hobby of match-making. As her husband sees her in their quiet evening together, she is blissfully ignorant. Yet Woolf lets us understand that she, too, stands for more than a symbol for the age and becomes the embodiment of what one might call the feminine, an aspect of mind that achieves its own sort of knowledge. In fact there is even a suggestion that she

might contain the genius that her husband so envies: "She was silent always. She knew then—she knew without having learnt. Her simplicity fathomed what clever people falsified" (TtL 46).

What does Mrs. Ramsay see with this instinctual knowing? Certainly she does not perceive life as any brighter or less difficult than does her husband. While he falls back on his work, she must deal with human worries, and "for the most part, oddly enough, she must admit that she felt this thing that she called life terrible, hostile, and quick to pounce on you if you gave it a chance. There were the eternal problems: suffering; death; the poor" (TtL 92). Yet all her energy is spent contradicting this vision of darkness, attempting to shine out in it, to achieve a vision of light, of significance and order behind the chaos. As Virginia Woolf worked from draft to final text, she underscored this healing quality in Mrs. Ramsay, who in the first version smooths James's hair and offers him hope "half mechanically" (TtLd 24) but by the published version is speaking the same words "compassionately" (TtL 26). When Mrs. Ramsay describes the fearful life of the Lighthouse-keepers, again in an addition to the draft, her first call is for empathy and her second for aid: "'How would you like that?' she asked, addressing herself particularly to her daughters. So she added, rather differently, one must take them whatever comforts one can" (TtL 12). It is clear even at this early point in the novel that Mrs. Ramsay understands the role of nurturer to be reserved for the female sex:

> Indeed, she had the whole of the other sex under her protection; for reasons she could not explain, for their chivalry and valour, for the fact that they negotiated treaties, ruled India, controlled finance, finally for an attitude towards herself which no woman could fail to feel or to find agreeable, something trustful, childlike, reverential; which an old woman could take from a young man without loss of dignity, and woe betide the girl—pray Heaven it was none of her daughters!—who did not feel the worth of it, and all that it implied, to the marrow of her bones! (TtL 13)

For Mrs. Ramsay, men and women are essentially different. The men rule the world and honor the women. But the women must protect the

men. Something that a woman has is essential to the life of humankind and provides a healing, unifying force in the face of pain, separation, and confusion.

If Mr. Ramsay, at his purest, masculine self, is condensed into a bare, spare channel marker in the sea of life, offering his gift of strong if limited certainty to those around him, Mrs. Ramsay has her own moment of wholeness in which she, too, can step away from the demands of daily life and become her essential self. The difference between the two scenes does much to define the masculine as against the feminine.

It is a rare moment when Mrs. Ramsay can escape from her obligations and become herself, untrammeled by the demands of others, especially those of her children whose lives are so much shaped by all around them in their youth.

> For this reason . . . it was a relief when they went to bed. For now she need not think about anybody. She could be herself, by herself. And that was what now she often felt the need of—to think; well, not even to think. To be silent; to be alone. All the being and the doing, expansive, glittering, vocal, evaporated; and one shrunk, with a sense of solemnity, to being oneself, a wedge-shaped core of darkness, something invisible to others. Although she continued to knit, and sat upright, it was thus that she felt herself; and this self having shed its attachments was free for the strangest adventures. When life sank down for a moment, the range of experience seemed limitless. (TtL 95–96)

When Mr. Ramsay becomes himself, he sheds beauty and affection to shrink to a well-defined, focused point. When Mrs. Ramsay becomes herself, she sheds her human attachments and is condensed into something invisible, limitless. Mr. Ramsay stands firmly on a narrow spit of land. Mrs. Ramsay ranges across continents. "Her horizon seemed to her limitless. There were all the places she had not seen; the Indian plains; she felt herself pushing aside the thick leather curtain of a church in Rome. This core of darkness could go anywhere, for no one saw it. They could not stop it, she thought, exulting. There was free-

dom, there was peace, there was, most welcome of all, a summoning together, a resting on a platform of stability" (TtL 96). In their own ways, Mr. and Mrs. Ramsay both discover stability as their purified selves. But while Mr. Ramsay feels the sea eating away the ground he stands on, Mrs. Ramsay feels her stability drawing all life into it. In fact he finds the finite and she the eternal: "there rose to her lips always some exclamation of triumph over life when things came together in this peace, this rest, this eternity" (TtL 96). The image that contains this vision serves as a complement to that representing Mr. Ramsay, for if he is the daylight channel marker, she is the light from the Lighthouse, reaching out into the darkness: "pausing there she looked out to meet that stroke of the Lighthouse, the long steady stroke, the last of the three, which was her stroke, for watching them in this mood always at this hour one could not help attaching oneself to one thing especially of the things one saw; and this thing, the long steady stroke, was her stroke" (TtL 96–97).

Like Mrs. Ramsay with her clear, unflinching vision of life's sorrow but her unending effort to reveal the peace and rest that lies behind it, the Lighthouse beam offers both severity and bliss:

> she looked at the steady light, the pitiless, the remorseless, which was so much her, yet so little her, which had her at its beck and call (she woke in the night and saw it bent across their bed, stroking the floor), but for all that she thought, watching it with fascination, hypnotised, as if it were stroking with its silver fingers some sealed vessel in her brain whose bursting would flood her with delight, she had known happiness, exquisite happiness, intense happiness, and it silvered the rough waves a little more brightly . . . and the ecstasy burst in her eyes and waves of pure delight raced over the floor of her mind and she felt, It is enough! It is enough! (TtL 99–100).

So Mr. Ramsay's truth pares away all subjectivity and seeks an unemotional certainty, while Mrs. Ramsay's is built out of the emotional, the subjective. His is as sure as the stone Lighthouse and insists on the savagery of the waves. Hers, too, admits the destructive yet expands to achieve a vision of wholeness, of the eternal, which

provides those moments of illumination that never fade in the mind. His is rational, hers intuitive, and both are set before us for admiration.

Though the perceptions of both Mr. and Mrs. Ramsay clearly have their value, it is difficult to imagine a way to bring them together. He sheds all vision. She embraces it. How to reconcile the two?

To begin with, Woolf makes it clear that even the most seemingly monolithic person is actually a collection of contradictions. Mr. Bankes, for example, as Lily sees him, is entirely impersonal and lacking in vanity, generous, pure-hearted, and heroic, but simultaneously a man who insists on bringing his valet all the way to the Hebrides, who is finicky about dogs on chairs, and who proses on about salt in vegetables until his hearers collapse in boredom (TtL 39–40). The Ramsays, too, are complex, contradictory human beings; and in that complexity lies hope for connection. Mr. Ramsay may attempt to remove beauty and emotion from his pursuit of truth, but on the sly he basks in the beauty of his wife and indulges in the poetic, quoting poetry (Tennyson and Cowper, it must be admitted, and not Shakespeare) as he paces about his garden for the sake of its "delicious emotion, this impure rhapsody of which he was ashamed but in which he revelled" (TtL 41–42). And Mrs. Ramsay, for all her leaving the life of social action to the men, has a secret desire to become "an investigator, elucidating the social problem" (TtL 18) and will mount her hobbyhorse of the model dairy whenever given a chance. So each contains hidden elements of the other.

One other bridge is available to the Ramsays to span the ravine that separates them, and that is their own emotions, which shift continually throughout the day. At the points when these emotions come together in harmony, they can unite the two very different persons who experience them.

Early in the novel, as a sort of trial run for successful reconciliation of opposites, Woolf offers us Charles Tansley, who, as a caricature of Mr. Ramsay, comes into sharpest contrast with Mrs. Ramsay, as she herself laughingly admits: "She said, the other day, something

about 'waves mountains high.' Yes, said Charles Tansley, it was a little rough. 'Aren't you drenched to the skin?' she had said. 'Damp, not wet through,' said Mr. Tansley, pinching his sleeve, feeling his socks" (TtL 15). If Mr. Ramsay is careful to speak only the truth as he sees it, Charles Tansley is fanatical. No hyperbole for him, not even the mildness of metaphor. As an atheist rather than an agnostic, he is unshakably certain about life's limits and is even more tightly confined within his own existence by his exaggerated self-absorption, far stronger than any Mr. Ramsay might exhibit. While Mr. Ramsay smiles at his wife's reading Shakespeare, Mr. Tansley proclaims with all the force of a bullhorn that women are beyond the pale of artistry. If he can be brought into harmony with Mrs. Ramsay, there is hope for larger reconciliations. And he can. What makes the impossible possible is a combination of human feeling and beauty.

From the outset, Charles Tansley inspires contradictory feelings in Mrs. Ramsay. On one page she likes him warmly. On the next she proclaims him "an awful prig—oh yes, an insufferable bore." But on the next again "now again she liked him warmly" (TtL 21–23). Under the influence of her affectionate feeling, he begins to loosen up, to abandon the rigid categories that have made his life so straitened, until "he was coming to see himself, and everything he had ever known gone crooked a little" (TtL 24). What pushes him over the edge and allows him to share the vision that Mrs. Ramsay perceives of the possibilities of human love as a force for unity, is her beauty:

> all at once he realised that it was this: it was this:—she was the most beautiful person he had ever seen.
> With stars in her eyes and veils in her hair, with cyclamen and wild violets—what nonsense was he thinking? She was fifty at least; she had eight children. Stepping through fields of flowers and taking to her breast buds that had broken and lambs that had fallen; with the stars in her eyes and the wind in her hair—He took her bag. . . . [F]or the first time in his life Charles Tansley felt an extraordinary pride; felt the wind and the cyclamen and the violets for he was walking with a beautiful woman. (TtL 25)

Under the power of love, Charles Tansley abandons literal language and plunges into the poetic, seeing in Mrs. Ramsay the figure of the loving, nurturing woman. Her beauty has broken through the barriers of the rational and has, for a moment, transformed him, brought him into the circle of her own vision. So the union of the male and the female may be possible, brought about by the particular, outreaching creativity that the woman carries with her.

Mr. and Mrs. Ramsay may not be divided by as large a gulf as that which separates Charles Tansley from Mrs. Ramsay, but the two of them do not make an easy marriage all the same, for they are persons of decided, often clashing, views and at times tend to judge each other harshly. Woolf provides us with a scene that both reveals the conflict and allows for the possibility of reconciliation when she places the two of them together to discuss James's longing for a trip to the Lighthouse. As usual, Mrs. Ramsay is hoping that her son may be able to make this symbolic voyage and, learning that the wind is blowing from an unpropitious direction, suggests that the wind may change. Mr. Ramsay's reaction is dramatic: "The extraordinary irrationality of her remark, the folly of women's minds enraged him. He had ridden through the valley of death, been shattered and shivered; and now, she flew in the face of facts, made his children hope what was utterly out of the question, in effect, told lies. He stamped his foot on the stone step. 'Damn you,' he said" (TtL 50).

In a world in which profanity pervades the dialogue of films and is common in the speech of college students, it is difficult to imagine the shock that such a word would have had when fired with venom at a refined Victorian woman. The symbolic weight of the word as a sign of the indecorous is suggested by Gilbert and Sullivan's song in which the proper captain of the *Pinafore never* uses "the big, big D." But Mr. Ramsay has been driven to extremes in seeing his form of truth challenged by "the irrational," the feminine. And Mrs. Ramsay perceives his masculine assertiveness with equal horror: "To pursue truth with such astonishing lack of consideration for other people's feelings, to rend the thin veils of civilisation so wantonly, so brutally, was to her so horrible an outrage of human decency that without re-

plying, dazed and blinded, she bent her head as if to let the pelt of jagged hail, the drench of dirty water, bespatter her unrebuked. There was nothing to be said" (TtL 51). The chances of harmony seem very remote.

Yet underlying the conflict between the Ramsays is a mutual admiration that allows each to pay homage to the perceptions of the other. All that is needed to bring this respect to the surface is for one to gesture toward the other's point-of-view; and Mr. Ramsay provides that act of humility by recognizing his wife's feelings in offering, very humbly, to consult the Coast Guard. It is not that she wants him to deny the truth as he sees it. She only wants him to present it with kindness, for in fact she appreciates the security that his certainty about facts provides her. So when he makes his gesture, she feels reverence for his views rise up in her, views that assert the immutable amid the shifting tide of emotion. "They came to her, naturally, since she was a woman, all day long with this and that; one wanting this, another that . . . she often felt she was nothing but a sponge sopped full of human emotions. Then he said, Damn you. He said, It must rain. He said, It won't rain; and instantly a Heaven of security opened before her. There was nobody she reverenced more. She was not good enough to tie his shoe strings, she felt" (TtL 51).

The fact of the matter is that Mrs. Ramsay, in ranging farther into the depths of human experience than does her husband, is threatened by greater danger. He stands on the solid shore of facts, objective truths that can be weighed and measured, while she sets out into the sea of the indefinable—emotion, the eternal, the visionary. She needs the "admirable fabric of the masculine intelligence" (TtL 159) to provide her with a point of reference. That is why, when she sits reading to her son and thinking her own private thoughts at the open French window of the house, she depends on the background murmur of her husband's conversation with Charles Tansley to keep the ephemeral nature of her days from rising up in a vision of the chaotic. While he speaks, nature seems tame, seems to provide a song of consolation as cantus firmus to her thoughts. But when the masculine security is gone, the fall of the waves "had no such kindly meaning, but like a

ghostly roll of drums remorselessly beat the measure of life, made one think of the destruction of the island and its engulfment in the sea, and warned her whose day had slipped past in one quick doing after another that it was all ephemeral as a rainbow" (TtL 27–28). A woman's day, as we have heard Woolf say, is made up of the passing, the fleeting; so a mooring to tie her boat to is a blessing. For the man, driven so firmly into the bed of the channel, on the other hand, the woman's gift of the spreading, the expansive, is equally important as a means to free him from his limitations. So if Mr. Ramsay offers his wife security, she offers him creativity, pouring "erect into the air a rain of energy, a column of spray, looking at the same time animated and alive as if all her energies were being fused into force, burning and illuminating (quietly though she sat, taking up her stocking again), and into this delicious fecundity, this fountain and spray of life, the fatal sterility of the male plunged itself" (TtL 58). She pours her whole self out for him, until "there was scarcely a shell of herself left for her to know herself by; all was so lavished and spent" (TtL 60), and he accepts her gift, filled and satisfied, with humble gratitude, as she accepted his.

There is no doubt that creativity, as Mrs. Ramsay enacts it, is sacrificial. It exhausts her even as it replenishes the vigor of her husband. But we are not meant to see the successful union of this couple as being represented by a sort of devouring of the wife by the husband. For Mr. Ramsay not only gives his wife a place to rest; he also respects her separateness. As she sits, a wedge-shaped core of darkness, casting off her "apparition" and becoming that inner self that "is all dark . . . all spreading . . . unfathomably deep" (TtL 96), her husband sees her isolation and will not interrupt her, though he longs to help her in her sadness, as he sees it, in her distance. She responds to his restraint by giving "him of her own free will what she knew he would never ask" and calling him to her. "For he wished, she knew, to protect her" (TtL 100). At its best, the relationship between these two people is one of balance and mutual support. The masculine and the feminine together are a complement symbolized by marriage.

But unity, as Woolf perceives it, is not achieved solely by the wed-

ding, literal and figurative, of a man and a woman. It is made possible also in the joining of other groups of people of various sorts in a wholeness that resembles, in its balance and harmony, a work of art. And because it is the men who insist on the fact of human separateness in Woolf's world, it is up to the women to create, or to reveal, this underlying unity.

In "The Window" section of *To the Lighthouse,* perhaps the most significant moment of coherence, one that contains the permanence and vividness of one of Virginia Woolf's moments of being, takes place at the Ramsays' dinner party. This party provides the ultimate challenge for Mrs. Ramsay's unifying skills, for at it are gathered such a motley assortment of mismatched human beings that it is a wonder they can find any point of connection. There, around the dinner table, sit Mr. Bankes, who much prefers eating alone; Charles Tansley, working-class rebel, who is forever proclaiming his own centrality and denying the significance of others; Lily Briscoe, whose painting he belittles and who is attempting to preserve her independence in the face of Mrs. Ramsay's urging her to marry; Paul and Minta, who are united through their new engagement but, as a result, removed from everyone else; Mr. Carmichael, absorbed in his opiate dreams; and six of the fidgeting Ramsay children. It is difficult to imagine a less promising collection of people for a hostess to coax into sociability, let alone unity.

Even the standard emotional ties that often join many of these people are missing. As they sit down to their soup, Mrs. Ramsay is at the ebb tide of her feeling for her husband. "She could not understand how she had ever felt any emotion or affection for him. She had a sense of being past everything, through everything, out of everything" (TtL 125). The one moment where she is in silent communication with him, their mind-reading dialogue is an unspoken quarrel about Mr. Carmichael's asking for extra soup. And others are equally detached from each other emotionally. Mr. Bankes is often enraptured by the beauty of Mrs. Ramsay. "Yet now, at this moment her presence meant absolutely nothing to him: her beauty meant nothing to him; her sitting with her little boy at the window—nothing, nothing" (TtL 134).

The natural clash between Lily Briscoe and Charles Tansley is not surprisingly at its peak at this inharmonious gathering; and if she asks, "Oh, Mr. Tansley . . . do take me to the Lighthouse with you. I should so love it," he judges correctly that she "was telling lies . . . was saying what she did not mean to annoy him, for some reason. She was laughing at him" (TtL 130); and he reacts accordingly. Finally when some common topic of conversation does seem to bring the diners together, "All of them bending themselves to listen thought, 'Pray heaven that the inside of my mind may not be exposed,' for each thought, 'The others are feeling this. They are outraged and indignant with the government about the fishermen. Whereas, I feel nothing at all'" (TtL 142).

This is the problem that confronts Mrs. Ramsay as she faces her guests, still exhausted from spending herself on her husband. "Nothing seemed to have merged. They all sat separate. And the whole of the effort of merging and flowing and creating rested on her" (TtL 126), for that is the woman's vocation. So, rousing herself to feel pity for the widowed Mr. Bankes, she begins the process of knitting the group together, not without reluctance, "as a sailor not without weariness sees the wind fill his sail and yet hardly wants to be off again and thinks how, had the ship sunk, he would have whirled round and round and found rest on the floor of the sea" (TtL 127).

Mrs. Ramsay may be the initiator, and finally the ultimate cause, of the incandescent moment of connection in which all her guests and family seem to share; but even she cannot bring her party together unless each person there is willing to relinquish a little of his or her own independence in order to reach out to the others. Lily is one of the first to answer Mrs. Ramsay's plea for compromise, through her silent cry "I am drowning, my dear, in seas of fire. Unless you apply some balm to the anguish of this hour and say something nice to that young man there, life will run upon the rocks." So, although she might, in other circumstances, maintain her feud with Charles Tansley, this time she turns to him in real kindness and asks, will he take her to the Lighthouse? And he, though her words are almost identical to those with which she taunted him earlier, judges "the turn in her mood

correctly—that she was friendly to him now" (TtL 138–39) and un-
bends, dropping his egotism and becoming friendly in return. Others,
too, bow to Mrs. Ramsay's unspoken demand for cooperation and
speak the bad French of empty small talk in order to work their way
toward more genuine communication. Thus gradually the merging
and flowing begin.

But Mrs. Ramsay does not depend entirely on the good will of
her guests to bring the party together. She also employs a number of
judiciously chosen props to suggest to those around the table the pos-
sibility of integrating the disparate. In the first place, there is Rose's
centerpiece, an "arrangement of the grapes and pears, of the horny
pink-lined shell, of the bananas" (TtL 146), which, in combining fruit
with the unexpected seashell, creates in effect a work of art, a central
line that brings all eyes that view it into common appreciation, even
when those eyes belong to people as generally uneasy with each other
as Mrs. Ramsay and Mr. Carmichael. Second, there are the candles,
lit just when the children threaten to break the growing harmony of
the dinner by laughing at their father. As the flames stoop and then
stand upright in the growing darkness, "the faces on both sides of the
table were brought nearer by the candle light, and composed, as they
had not been in the twilight, into a party round a table, for the night
was now shut off by panes of glass, which, far from giving any accu-
rate view of the outside world, rippled it so strangely that here, inside
the room, seemed to be order and dry land; there, outside, a reflection
in which things wavered and vanished, waterily" (TtL 146–47). The
emphasis on composition and order suggests that the candles, like the
centerpiece, function to bring artistic balance to the dinner. Even the
pièce de résistance, the Boeuf en Daube, unlike a roast of beef or mut-
ton, offers the diners an image of dissimilar objects brought into
union, for it took three days to marry the flavors of "the confusion of
savoury brown and yellow meats and its bay leaves and its wine" (TtL
151). The effort was worth it, for as soon as Mr. Bankes tastes it, "All
his love, all his reverence," for Mrs. Ramsay returns (TtL 151), and
he becomes part of the whole she has created.

So at last, through the planning of the meal, the setting of the

table, the lighting of the candles, through the effort of bringing her unwilling guests to talk kindly to one another, Mrs. Ramsay has built up one of those short-lived yet, paradoxically, immortal moments that reveal the pattern behind appearances and make life stand still as a work of art. She looks around her table and feels the moment glowing around her, thinking,

> Everything seemed possible, Everything seemed right. . . . [i]t arose . . . from husband and children and friends; all of which rising in this profound stillness . . . seemed now for no special reason to stand there like a smoke, like a fume rising upwards, holding them safe together. Nothing need be said; nothing could be said. There it was, all round them. It partook, she felt, carefully helping Mr. Bankes to a specially tender piece, of eternity; as she had already felt about something different once before that afternoon; there is a coherence in things, a stability; something, she meant, is immune from change, and shines out . . . in the face of the flowing, the fleeting, the spectral, like a ruby; so that again tonight she had the feeling she had had once today already, of peace, of rest. Of such moments, she thought, the thing is made that endures.
>
> "Yes," she assured William Bankes, "there is plenty for everybody." (TtL 157–58)

And indeed there is.

Such moments, of course, as Mrs. Ramsay knows, cannot last, but while they surround one, they illuminate reality and give it the quality of art, joining all the parts of existence so that "at the same time, one can see the ripple and the gravel," the surface and the depths, reconcile "something to the right, something to the left," so that "the whole is held together," (TtL 160) as Lily hopes to unite the masses in her painting. The one who at this moment joins the right to the left is Mrs. Ramsay, whose eyes, in an image of the Lighthouse beam we have grown to associate with her, "seemed to go round the table unveiling each of these people, and their thoughts and their feelings, without effort like a light stealing under water so that its ripples and the reeds in it and the minnows balancing themselves, and the sudden silent trout are all lit up hanging, trembling" (TtL 160). She cannot

rest in this moment for long, for she has not yet completed her work of unifying for the evening—"It was necessary now to carry everything a step further" (TtL 167); yet while she stands looking at her guests, she seems to have created a moment of being not just for herself but for all of them, a fact that Lily recognizes when she notes that directly after Mrs. Ramsay leaves the room "a sort of disintegration set in; they wavered about, went different ways" (TtL 168).

When Mrs. Ramsay arises from the table, having united her friends and her family in a luminous moment of order and permanence, two of her children have missed the wonder of the gathering. Prue and Andrew, who look to be the direct inheritors of their parents' gifts, have been included in the vision. But James and Cam, the unformed youngest of the large clan, are in bed in the nursery, being too young to join their elders at the formal dinner. James, as we have already seen, is a strange unmixed combination of his father and mother. Cam is a mystery to both parents: "She was off like a bird, bullet, or arrow, impelled by what desire, shot by whom, at what directed, who could say?" (TtL 84). The future of both has not yet come into focus. But as Mrs. Ramsay enters the nursery and finds the two at odds, the possibility that they may align themselves with the masculine or the feminine is already clear. The bone of contention on this magical evening is the skull of a boar that has been nailed to the wall. James, like his father, who insists uncompromisingly that death and the other ugly facts of life must be faced unflinchingly, will not have the skull touched. Cam, like her mother, who senses the fearful implications of these facts as she sails out over the deeps of human experience, sees the shadow of the skull everywhere and cannot go to sleep while it haunts the room. Once again it is up to Mrs. Ramsay to bring resolution to two discordant notes, and she does it by asserting the value of both. She wraps the skull in her shawl and transforms it into "a beautiful mountain such as she had seen abroad, with valleys and flowers and bells ringing and singing and little goats and antelopes" (TtL 172);[40] yet, as she points out to James, "the boar's skull was still there; they had not touched it" (TtL 173). Both views are true. One need not assert one in contradiction of the other. So she has brought

harmony to Cam and James as she brought it to the others. And "children don't forget" (TtL 97).

Her work completed within the limits of her calling as hostess and mother, Mrs. Ramsay can now rest in silence at her husband's side, reading a love sonnet that expresses her feelings indirectly, and sitting in peace. Yet even now one further demand is made of her, for she senses that her husband wants her to tell him, in so many words, "I love you." An easy request to grant, one would think. But not for Mrs. Ramsay. "He could say things—she never could. . . . A heartless woman he called her; she never told him that she loved him. But it was not so—it was not so. It was only that she never could say what she felt." (TtL 185). Lily Briscoe recognizes the reason behind Mrs. Ramsay's silence, realizes that Mrs. Ramsay would think, as she sat unspeaking, "Aren't things spoilt then . . . by saying them? Aren't we more expressive thus?" (TtL 256) Because love is the most sacred aspect of life for Mrs. Ramsay, she will not narrow its power by confining it in language. So she tells her husband that she loves him in another way, saying, "'Yes, you were right. It's going to be wet tomorrow. You won't be able to go.' And she looked at him smiling. For she had triumphed again. She had not said it: yet he knew" (TtL 186). By affirming his own vision, that one cannot go to the Lighthouse, she has offered her own, that, in a symbolic way, as she demonstrates in her very words and actions, one can.

Love, for Mrs. Ramsay, provides all hope for connection in the world. As she looks to the triumph of the dinner party, she attributes it to love, specifically the power of love manifested in the engagement of Paul and Minta. If one were to ask her to separate out from the evening that ruby of permanence into which the party was momentarily crystallized, "the thing that mattered; to detach it; separate it off; clean it of all the emotions and odds and ends of things, and so hold it before her, and bring it to the tribunal where, ranged about in conclave, sat the judges she had set up to decide these things" (TtL 169), it is human love they would judge; it is love that, as she sees it, "struck everything into stability" (TtL 170). So she assumes that the community of feeling that she created will be carried on by Paul and

Minta when she is dead (TtL 171). For her, marriage is dependent on love, the quality she does not like to name (TtL 93), "the thing she had with her husband," and marriage embodies it. Thus it is appropriate that Minta and Paul should arrive at dinner just as the Boeuf en Daube is brought in, since the dinner is for Mrs. Ramsay a celebration of their union. "[F]or what," she thinks, "could be more serious than the love of man for woman, what more commanding, more impressive, bearing in its bosom the seeds of death; at the same time these lovers, these people entering into illusion glittering eyed, must be danced round with mockery, decorated with garlands" (TtL 151). Yet she knows, even as she proclaims its sacredness, that human love reveals its limitations. It is of the utmost importance, yet it is tied to mortality. It is the essence of truth yet also is illusion. Still, from her position in her own society, it seems the only possible route to happiness and fulfillment. But this Victorian concept of love, offered up so forcefully by Mrs. Ramsay, is not presented as a vision that all will readily adopt. It falls short, particularly for her daughters, who are standing on the brink of the modern age; and they rebel secretly against the sort of life their mother has so clearly presented for them: "it was only in silence, looking up from their plates, after she had spoken so severely about Charles Tansley, that her daughters, Prue, Nancy, Rose—could sport with infidel ideas which they had brewed for themselves of a life different from hers; in Paris, perhaps; a wilder life; not always taking care of some man or other; for there was in all their minds a mute questioning of deference and chivalry, of the Bank of England and the Indian Empire, of ringed fingers and lace, though to them all there was something in this of the essence of beauty" (TtL 14). Mrs. Ramsay's vision has an awesome beauty, but it does not seem the only way for a woman to see the world. In fact the engagement of Paul and Minta calls up discomfort in Nancy and Andrew as they accompany the lovers on a beach walk. "They had not wanted this horrid nuisance to happen," they think, after coming across the lovers in an embrace; "it irritated Andrew that Nancy should be a woman, and Nancy that Andrew should be a man, and they tied their shoes very neatly and drew the bows rather tight" (TtL 116). None of

the undisciplined fervor of love for them! This union of the sexes seems to restrict one's individuality. Even Minta, for all her joy, does not go into her engagement with unmixed feelings, as Nancy notices when Minta weeps for the loss of her brooch: "it might be true that she minded losing her brooch, but she wasn't crying only for that. She was crying for something else. We might all sit down and cry," Nancy feels (TtL 117); for marriage is a loss as well as a gain and love of this sort is not for everyone.

If Mrs. Ramsay's daughters view love with some skepticism, they are not the only ones to resist the spell of intimate connection between a man and a woman and to deflect Mrs. Ramsay's advances from this direction, however gently she tries. Mr. Carmichael, on the particular September afternoon during which the events of "The Window" unfold, consistently keeps Mrs. Ramsay at bay. She reaches out with her habitual gesture of a woman toward a man, offering service, assistance, and he declines. A poet, Mr. Carmichael spends his days like a cat watching birds, pouncing on the words he wants as they fly into his mind, and like a cat, too, he maintains his detachment from the human world and lies basking on the lawn "with his yellow cat's eyes ajar, so that like a cat's they seemed to reflect the branches moving or the clouds passing, but to give no inkling of any inner thoughts or emotions whatsoever" (TtL 19). Mrs. Ramsay knows that he is unhappy and comes to them to escape an unsuccessful marriage, and she does everything she can to make him feel welcome, but somehow he does not trust her. "[H]e would have liked to reply kindly to [her] blandishments (she was seductive but a little nervous) but could not" (TtL 19), for his generalized view of life is incompatible with hers and fights against her own instinct for action and self-sacrifice. Confronted with his lack of receptiveness, she is made aware of the weakness in her own chosen methods, "of the pettiness of some part of her, and of human relations, how flawed they are, how despicable, how self-seeking, at their best" (TtL 65–66). When she offers herself and her offer is refused, she begins to wonder whether her gift has been a form of selfishness, manipulating others and calling attention to herself.

Another major figure in this novel who cannot accept without

reservation Mrs. Ramsay's panacea of human relationships, especially those encompassed by love and marriage, is Lily Briscoe. Like Mr. Carmichael, Lily values her independence. She does not enjoy squeezing herself into the corsets of prescribed social behavior, or perhaps one might better say the tight shoes, for, as Mr. Bankes notices, "Her shoes were excellent. . . . They allowed the toes their natural expansion" (TtL 31); and in this she has more in common with the moor-striding Mr. Ramsay in his custom-made boots than with Mrs. Ramsay. For Lily pursues honesty without compromise, as an artist must, and honesty may, at least occasionally, stand in the way of easy social intercourse let alone the self-sacrificial service Mrs. Ramsay asks of women.

Virginia Woolf makes very clear that Lily's honesty allows her to see accurately into the hearts of others. When Charles Tansley sits aching to break into the conversation, "Lily Briscoe knew all that. Sitting opposite him, could she not see, as in an X-ray photograph, the ribs and thigh bones of the young man's desire to impress himself, lying dark in the mist of his flesh" (TtL 137). And when Mrs. Ramsay, at the outset of the dinner, imagines herself sailing away from her guests and must consciously come about into the wind and let her sails refill for the return trip by pitying Mr. Bankes, Lily can read both the image and the emotion: "when she turned to William Bankes, smiling, it was as if the ship had turned and the sun had struck its sails again, and Lily thought with some amusement because she was relieved, Why does she pity him?" (TtL 127). Such clarity of vision is a gift in its own right and may allow for the embracing of all forms of truth in a way different from that achieved by Mrs. Ramsay. But Mrs. Ramsay cannot keep herself from casting Lily in her own mold, and Lily knows it: just as Mrs. Ramsay, seeing Lily and William Bankes together, is struck with the "admirable idea" that the two should marry, Lily, acknowledging outwardly Mrs. Ramsay's smile, realizes inwardly, "oh, she's thinking we're going to get married" (TtL 111).

One would think that Lily, determined to maintain the artist's independence of thought and the detachment necessary for accurate observation, would have little difficulty resisting the vision of mar-

riage that Mrs. Ramsay holds out to her. But even as the Ramsay daughters acknowledge the essential beauty in their mother's nature, so Lily acknowledges the wonder in the symbolic power of marriage. Mr. and Mrs. Ramsay, in *To the Lighthouse,* become representatives of the union of the masculine and the feminine and so never lose their identities as "Mr." and "Mrs.," halves of a couple, and Lily is allowed a moment of revelation in which this function of the two becomes clear to her. "[S]uddenly the meaning which, for no reason at all, as perhaps they are stepping out of the Tube or ringing a doorbell, descends on people, making them symbolical, making them representative, came upon them, and made them in the dusk standing, looking, the symbols of marriage, husband and wife" (TtL 110–11). Such mythic figures must loom large on anyone's horizon; and, living in the last days of the Victorian era, Lily finds them rising up enormous in her life. Yet timidly, but with intensity, she resists the call to enact a similar symbolic role: "Oh, but, Lily would say, there was her father; her home; even, had she dared to say it, her painting. But all this seemed so little, so virginal, against the other. Yet, as the night wore on . . . gathering a desperate courage she would urge her own exemption from the universal law; plead for it; she liked to be alone; she liked to be herself; she was not made for that; and so have to meet a serious stare from eyes of unparalleled depth, and confront Mrs. Ramsay's simple certainty . . . that her dear Lily, her little Brisk, was a fool" (TtL 77–78).

If marriage, and the constrictions it puts on one's independence, are clearly something Lily, as an artist, was not made for, love by itself remains a greater temptation. In fact, throughout "The Window" Lily alternates between pursuing love and fleeing from it. Part of Lily is full of love, not least for Mrs. Ramsay and all the security she represents. When Lily is most assailed by doubts about her chosen, virginal life, she longs to throw herself "at Mrs. Ramsay's knee and say to her—but what could one say to her? 'I'm in love with you?' No, that was not true. 'I'm in love with this all,' waving her hand at the hedge, at the house, at the children" (TtL 32); for Lily suspects that Mrs. Ramsay holds in the chambers of her mind and heart "tablets bearing

sacred inscriptions, which if one could spell them out, would teach one everything" (TtL 79). What Lily wants from Mrs. Ramsay is not knowledge as Mr. Ramsay would define it. What she wants to learn is "unity . . . intimacy itself, which is knowledge" (TtL 79). And we have seen from the dinner party that Mrs. Ramsay, at the height of her powers, can join what is on the right hand to what is on the left to form just this unity. She draws her powers for making the world one from her belief in love, "in this strange, this terrifying thing, which made Paul Rayley, sitting at her side, all of a tremor, yet abstract, absorbed, silent" (TtL 152).

No wonder that Lily, in all her honesty, acknowledges love's power: "It came over her too now—the emotion, the vibration, of love. How inconspicuous she felt herself by Paul's side! He, glowing, burning; she, aloof, satirical; he, bound for adventure; she, moored to the shore; he, launched, incautious; she, solitary, left out—and, ready to implore a share" (TtL 153). As she sits, warmed, even scorched, by the heat of Paul's love, Lily finds it beautiful and exciting, yet also stupid and barbaric. She understands why "from the dawn of time odes have been sung to love" yet suspects, judging from her own experience, that women "would all the time be feeling, This is not what we want; there is nothing more tedious, puerile, and inhumane than this; yet it is also beautiful and necessary" (TtL 155). Under this pressure of contradictions, a basic recognition of love's beauty, yet a sense that women do not want it as the chief end of their lives, Lily finds promise of an alternate path to satisfaction, to harmony—her painting. So "she need not marry. . . . She was saved from that dilution. She would [in her painting] move the tree rather more to the middle" (TtL 154). Art may hold out the possibility of a different sort of unity and intimacy than that offered by the love that Mrs. Ramsay believes in— different, though no less important, no less satisfying.

But art, in its literal form, is not necessarily the only alternative to romantic love as a means to union in the emerging modern world; and it is not only the younger generation of women who suggest that Mrs. Ramsay's idea of love is only one way of promoting order and permanence in life. For in the figure of Mr. Bankes, Virginia Woolf

offers us love and art in yet another aspect, creating a vision that makes it plain that Mr. and Mrs. Ramsay represent the masculine and the feminine only as a convenience. One's particular gender does not necessarily open one to a single point of view, and an enlightened point of view, the way in which one perceives reality, is the vision that stands behind both successful love and successful art.

Mr. Bankes, like Lily Briscoe, has purposefully kept himself apart, since the death of his wife, from the limited circle circumscribed by marriage. He travels light, having no children, and has maintained a variety of friendships with his independence and mobility. For him, the center of his days is his scientific work. Yet he, also like Lily, feels a certain lack of fruitfulness in such an existence. Even while concluding that Mr. Ramsay's wife and children have destroyed some of the vigor of his friend's philosophical thinking, Mr. Bankes also acknowledges that they gave him something and wishes that Cam would stick a flower in his own lapel that he might have a share in it. When she does not, "he felt aged and saddened and somehow put into the wrong by her about his friendship. He must have dried and shrunk" (TtL 36). But for all his occasional qualms about having elected not to remarry and have children, "the truth was that he did not enjoy family life" (TtL 134). He finds it trifling and boring, "compared with the other thing—work" (TtL 134). Yet absorption in his work limits him in its own way, for it protects him from asking the large questions that family life calls forth: "What does one live for? . . . Is human life this? Is human life that?" (TtL 134–35). Mr. Bankes needs some contact with the world of intimacy to shed light on such questions, light that his laboratory may not provide.

Work is part of one's access to knowledge, but love in some form is also necessary. Mr. Bankes, as he stands on the lawn looking at Mrs. Ramsay and her son, demonstrates to us and to Lily that there are forms of love equal in power to that recommended by the advocates of marriage. His love for Mrs. Ramsay, as Lily sees, is of this kind.

It was love . . . distilled and filtered; love that never attempted to clutch its object; but, like the love which mathematicians bear their

symbols, or poets their phrases, was meant to be spread over the world and become part of the human gain. So it was indeed. The world by all means should have shared it, could Mr. Bankes have said why that woman pleased him so; why the sight of her reading a fairy tale to her boy had upon him precisely the same effect as the solution of a scientific problem, so that he rested in contemplation of it, and felt, as he felt when he had proved something absolute about the digestive system of plants, that barbarity was tamed, the reign of chaos subdued. (TtL 73–74)

Whereas the passionate love felt by Paul Rayley threatens Lily with its cruelty, Mr. Bankes's love has a totally different effect: "[N]othing so solaced her, eased her of the perplexity of life, and miraculously raised its burdens, as this sublime power, this heavenly gift. . . . That people should love like this, that Mr. Bankes should feel this for Mrs. Ramsay . . . was helpful, was exalting" (TtL 74).

This impersonal love is strangely like the aesthetic emotion praised by Roger Fry and even echoes, in Woolf's description of it, the language he uses to explain it as he "envisage[s] the possibility of some kind of abstract form in the aesthetic contemplation of which the mind would attain satisfaction—a satisfaction curiously parallel to that which the mind gets from the intellectual recognition of abstract truth" or to those cases "of mathematical relations which it is beyond [one's] powers to prove" (V&D 80, 81). It is beginning to seem possible that love and art can achieve similar ends by different means, that love may in fact be a sort of art, and art a sort of love. When Lily sees Mr. and Mrs. Ramsay embodying "being in love," "life, from being made up of little separate incidents which one lived one by one, became curled and whole like a wave which bore one up with it and threw one down with it, there, with a dash on the beach" (TtL 73). In the same way art, when it is successful, brings together all the disparate elements of life and unites them in a whole.

Perhaps because Mr. Bankes can feel for Mrs. Ramsay a love that maintains a detachment and a universality that passionate love misses but art often achieves, he is open to perceiving other aspects of life with the eye of the artist and to accepting Lily's abstract rendering of

Mrs. Ramsay even though his personal fondness for art has been for the more representational sort. Roger Fry in his essay on aesthetics admits that there is beauty in nature and that "any object may . . . compel us to regard it with that intense disinterested contemplation that belongs to the imaginative life" (V&D 37), though he is reluctant to treat the natural world in the same terms as the aesthetic. Woolf, however, feels no such reluctance and sets Lily and Mr. Bankes together to look out at the dunes and the sea with all the pleasure of connoisseurs enjoying a masterpiece. They react to the blue of the bay and the "prickly blackness on the ruffled waves" (TtL 33) with just that balancing of emotions that Fry says are called up by the interplay of color and mass in a painting; and they seek a harmony of forms "with a natural instinct to complete the picture" (TtL 34) as they set the movement of a sailboat against the stillness of the faraway sandhills.

When Mr. Bankes, then, turns to Lily's picture, he is able to listen intelligently and sympathetically to her explanation of the need to allow abstraction to create a balance of forms, since he can look at the scenery with the same objective eye:

> Simple, obvious, commonplace, as it was, Mr. Bankes was interested. Mother and child then—objects of universal veneration, and in this case the mother was famous for her beauty—might be reduced, he pondered, to a purple shadow without irreverence.
>
> But the picture was not of them, she said. Or, not in his sense. There were other senses too in which one might reverence them. By a shadow here and a light there, for instance. Her tribute took that form if, as she vaguely supposed, a picture must be a tribute. (TtL 81)

So Lily and Mr. Bankes offer a hint that the best values of the Victorian Age, if purified and distilled, may carry over into the future. Love need not be restricted to marriage. One may love without possessing; art need not imitate life but may pay tribute to beauty in untraditional ways. It is their sharing of this understanding that allows Lily to say, after gaining perspective through the passage of time, "One could talk of painting then seriously to a man. Indeed, his friendship

had been one of the pleasures of her life. She loved William Bankes" (TtL 263). Not, of course, as Mrs. Ramsay would have expected. But Mrs. Ramsay's vision, however comprehensive, is still restricted by the conventions of her age. The future may confirm it, but in ways that would surprise her.

Mrs. Ramsay believes in love and uses it to set in equilibrium the separate objects, in this case human beings, that are gathered before her. For the most part she preaches marriage as the way to this equilibrium. If that were her whole sermon, an age that denied the universality of marriage would leave her totally behind. But Mrs. Ramsay embodies more than the Victorian matchmaker. She is, as we have seen, something of the essential feminine, and as such she contains within herself the promise for a different sort of life than the one she lives. Her own description of love, with its hint of illusion and mortality, suggests, as we saw, her awareness of the limits of her personal solution to life's cacophony. She is aware, too, that marriage is not necessarily the answer, realizing that "she was driven on, too quickly she knew, almost as if it were an escape for her too, to say that people must marry; people must have children" (TtL 92–93). She can even imagine that her daughters might find a different, perhaps better, way to live. "They must find a way out of it all," she thinks. "There might be some simpler way, some less laborious way. . . . When she looked in the glass and saw her hair grey, her cheek sunk, at fifty, she thought, possibly she might have managed things better—her husband; money; his books. But for her own part she would never for a single second regret her decision, evade difficulties, or slur over duties" (TtL 13–14). She has chosen her own path and will walk it bravely, but she is open to the possibility of others.

It is not only in her doubts about love and marriage that we see Mrs. Ramsay pointing toward a different future; for in her own life she enacts the artist's role that Lily is attempting in another medium, a fact that Lily can grasp only when she is able to see Mrs. Ramsay in perspective. But, for the reader, Mrs. Ramsay's artistry should be clear even in "The Window." Virginia Woolf consistently associated her mother with painters and paintings, describing her as a

Cézanne portrait, imagining a picture of her life in terms of colors and abstract shapes (MoB 66). This emphasis on art carries over to the portrayal of Mrs. Ramsay, who not only creates like an artist, bringing together the mass on the right with the mass on the left until "the whole is held together," but also sees and values art for itself. Her pleasure in Rose's centerpiece is that felt by a knowledgeable viewer of art, in Fry's terms, for she puts "a yellow shape against a purple, a curved shape against a round shape" (TtL 163) in a pure appreciation of forms. Her ability to delight in the abstract, the impersonal, brings her into harmony with Augustus Carmichael, who has otherwise avoided her all day. Seeing that he shares her contemplation of the arrangement of fruit and shells, she realizes that, although they experience the centerpiece differently, "looking together united them" (TtL 146).

Art brings them together again later during the dinner, this time in the form of a poem that Mr. Carmichael stands chanting like a priest as Mrs. Ramsay walks out of the room. He seems to connect the refrain with her, and, as she passes, he bows "to her as if he did her homage" (TtL 167). If he assumes that she is in accord with him and the poem he recites, he is right, for she finds herself reflected in the words just as a sensitive viewer finds himself reflected in a great painting, as Fry asserts. "And all the lives we ever lived and all the lives to be are full of trees and changing leaves" runs the poem. "She did not know what they meant, but, like music, the words seemed to be spoken by her own voice, outside herself, saying quite easily and naturally what had been in her mind the whole evening, while she said different things" (TtL 166).

The tree in the poem remains the same tree, even though its leaves change, and feminine creativity is the same force, though it may manifest itself in different forms at different times. In fact the tree itself in this novel gradually associates itself with this particular creative power. Lily, to bring her painting into stasis, plans to move a tree to the center. Mrs. Ramsay, recovering from the dissolution of her party, "quite unconsciously and incongruously, used the branches of the elm trees outside to help her to stabilise her position. Her world was

changing: they were still. The event had given her a sense of move-ment. All must be in order. She must get that right and that right, she thought, insensibly approving of the dignity of the trees' stillness" (TtL 169). Finally, Mrs. Ramsay herself "grew still like a tree which has been tossing and quivering and now, when the breeze falls, settles, leaf by leaf, into quiet" (TtL 177). We may begin to understand that the artistry that is embodied by Mrs. Ramsay, when purged of the chatter of the particular age in which she lives, may be moved to the center of Lily's painting and be claimed by Lily as her own artistry, merely a different form of love.

But before Lily can complete her painting, before the moment of peace and stability achieved at the Ramsays' dinner table can be con-firmed in the larger span of things, the old order must give way to the new; old patterns must be broken to provide materials from which to construct the patterns to be. In "The Window," Mrs. Ramsay's pres-ence is so strong that it is nearly impossible to see her in perspective, understand what it is in her visions that is essential and what idiosyn-cratic, ephemeral. Perhaps, if the world she lived in had never changed, it would be unnecessary to distinguish between the fleeting and the lasting in her views. But that world did change. Death, war, and the passage of time created a great rift between the Victorian and the modern. This upheaval, in the novel, offers the survivors a chance to gain that distance they need to see in perspective the past, them-selves, and the relationship between the two.

"Time Passes"

"Time Passes" serves as a line drawn down the middle of *To the Lighthouse*. On one side is the past, the Victorian Age, in which Mrs. Ramsay reigns and Lily Briscoe plays a minor role. On the other is the present, the postwar world, in which Mrs. Ramsay and much that she represented are dead and Lily must struggle to make sense of the changes that have taken place. From the open-ing of this section with its chantlike speeches, we are thrown abruptly

into a highly symbolic world in which uncertainty is the dominating refrain:

> "Well, we must wait for the future to show," said Mr. Bankes. . . .
> "It's almost too dark to see," said Andrew. . . .
> "One can hardly tell which is the sea and which is the land," said
> Prue. (TtL 189)

Engulfing darkness, an unknown future, loss of definition, these make up the litany of the passing of time. For one of the functions of this section is to present the destruction (or apparent destruction) of all that "The Window" made firm.

Virginia Woolf begins the process of change by calling up the darkness, an appropriate move, since the passage of time is measured in the movement from day to night to day. But this initial darkness seems particularly immense, consuming, "with the lamps all put out, the moon sunk" and a downpouring of rain. "Nothing, it seemed [and the qualifier is an addition to the draft], could survive the flood, the profusion of darkness" (TtL 189). With its invasion, not only are material objects swallowed up, but "there was scarcely anything left of body or mind by which one could say, 'This is he' or 'This is she'" (TtL 190). When Mr. Carmichael blows out his candle, then, the gesture almost seems to destroy all hope of a rebirth of light.

Under ordinary circumstances, even the longest night is followed by dawn, but with poetic license Virginia Woolf, in announcing the destructive darkness, cancels bright day, saying: "Night, however, succeeds to night. The winter holds a pack of them in store and deals them equally, evenly, with indefatigable fingers. They lengthen; they darken" (TtL 192). It is when the darkness seems endless that the greatest blow descends: Mrs. Ramsay, who throughout the first section is associated with the light, dies, leaving an echoing void in a "dark morning" (TtL 194). At her death, even the dawn is dark, and throughout "Time Passes" the signs of her influence are gradually erased, gradually, but with a fearful effect: "once in the middle of the night with a roar, with a rupture, as after centuries of quiescence, a

rock rends itself from the mountain and hurtles crashing into the valley, one fold of the shawl loosened and swung to and fro" (TtL 195–96).

Mrs. Ramsay, in "The Window," assumed the almost allegorical role of the Victorian woman. Her death might seem to announce the end of an age. But as she prepared for her party that September evening, she had about her two well-trained heirs who promised to keep her values alive. Prue, the beauty, was to marry like her mother and carry on the torch of service; Andrew, the budding mathematician, was to live the life of the purely rational Victorian man. So we might hope to see another generation of Ramsays springing up at the graveside of the old. "Time Passes," however, destroys that hope. For it is not just Mrs. Ramsay who dies there but Prue and Andrew as well. Children, Mrs. Ramsay's fortune, are denied to Prue; in fact it is pregnancy that kills her. Some other form of creativity must be sought, perhaps, for women in the modern world. And the war, which sends its shock waves through the landscape, shocks that "further loosened the shawl" (TtL 200), kills Andrew, and hundreds of thousands like him, forcing young men as yet unformed in the Victorian mold to assume their brothers' places and reevaluate the world in which they live.

So there comes a moment in "Time Passes" when the forces of destruction seem to have prevailed: "The house was left; the house was deserted. It was left like a shell on a sandhill to fill with dry salt grains now that life had left it. The long night seemed to have set in; the trifling airs, nibbling, the clammy breaths, fumbling, seemed to have triumphed" (TtL 206). All that Mrs. Ramsay built—that shape of almost mystical permanence, glimpsed only, but vividly real, that vision of life as a work of art, revealing order beneath the chaos—has Woolf denied its truth?

"Time Passes" serves as a symbol of the shattering change that took place in the early years of the twentieth century, but it functions also, paradoxically, to affirm the continual existence of meaning, of pattern behind appearances, even in the face of the greatest upheaval. "It seemed," and assorted other qualifying phrases are scattered like a

fling of seed throughout the darkest portions of this section, assuring us that what appears chaotic, bleak, hopeless, may be nothing of the kind. Time, as well as defeating a number of our expectations, may also reveal a larger order behind the apparent lack of continuity.

Virginia Woolf begins the rebuilding of her pattern with the suggestive arrangement of her images. In the opening pages of this section she piles darkness upon darkness, night upon night, until the culminating gloom of Mrs. Ramsay's death seems to preclude any dream of dawn. But, having allowed us to fear that night might actually succeed to night, she then, immediately after Mrs. Ramsay dies, introduces a long stretch of light: "Now, day after day, light turned, like a flower reflected in water, its sharp image on the wall opposite" (TtL 194). As the section continues and she alternates light and darkness, we begin to recognize a pattern emerging. If it is dark, day will follow. And if it is day, dark will follow. The rhythm of life can be predicted. Moments of illumination cannot last, perhaps, but neither can moments of despair.

This alternating rhythm of light and darkness finds its philosophical reflection in another pattern that Woolf builds into "Time Passes," that pattern of hope and emptiness that marks the search of those who seek an answer to the question "What is the meaning of life?" The possibility of an answer, a vision of ultimate reality, of permanence, and the fact that such answers are set in a broad background of questioning are introduced early in the section:

> It seemed now as if, touched by human penitence and all its toil, divine goodness had parted the curtain and displayed behind it, single, distinct, the hare erect; the wave falling; the boat rocking, which, did we deserve them, should be ours always. But alas, divine goodness, twitching the cord, draws the curtain; it does not please him; he covers his treasures in a drench of hail, and so breaks them, so confuses them that it seems impossible that their calm should ever return or that we should ever compose from their fragments a perfect whole or read in the littered pieces the clear words of truth. For our penitence deserves a glimpse only; our toil respite only. (TtL 192–93)

To create the pattern of questions unanswered, questions answered, Woolf peoples "Time Passes" with a series of dreamers who walk the beach. The first ventures out just before the death of Mrs. Ramsay, "fancying that he might find on the beach an answer to his doubts" but "no image with semblance of serving and divine promptitude comes readily to hand bringing the night to order and making the world reflect the compass of the soul." So the dreamer retreats indoors, thinking, "Almost it would appear that it is useless in such confusion to ask the night those questions as to what, and why, and wherefore, which tempt the sleeper from his bed to seek an answer" (TtL 193). *Almost,* for a few pages later "[t]he mystic, the visionary, walking the beach on a fine night, stirring a puddle, looking at a stone, asking themselves 'What am I,' 'What is this?' had suddenly an answer vouchsafed them: (they could not say what it was) so that they were warm in the frost and had comfort in the desert" (TtL 197–98). These glimpses of eternity given to the dreamers, beyond the reach of words, as we might expect from Mrs. Ramsay's silences, are visions of an underlying unity, a marriage of humanity and the universe that results in an image of wholeness, "of flesh turned to atoms which drove before the wind, of stars flashing in their hearts, of cliff, sea, cloud, and sky brought purposely together to assemble outwardly the scattered parts of the vision within" (TtL 198). Such glimpses lead the dreamers to search further for "some absolute good; some crystal of intensity . . . single, hard, bright, like a diamond in the sand" (TtL 199), or like that "something" Mrs. Ramsay sees at her dinner, which "shines out . . . like a ruby" (TtL 158), rendering "the possessor secure" (TtL 199).

But visions, however intrinsically limitless in themselves, are embedded in the cotton wool of life and thus surrounded by vacancy and doubt. Night succeeds to day as day to night. So these answers that the seekers find fade, threatened by death, by war, until the beach walkers leave their meditations, the mirror of their vision temporarily broken. Yet even as they turn, despairing, Mr. Carmichael brings out a volume of poems, as if to suggest the existence of a channel marker of art standing firm in the dark current of the war years (TtL 202).

The sure hope of order, of unity, behind the disorder of change

and destruction is not a certainty easily won. Woolf makes clear that the threat of chaos is very real, if finally unrealized. She uses the gradual decay of the Ramsays' house to reflect this danger and offers us a picture of a world in which human beings are absent, where "the flowers standing there, looking before them, looking up, yet beholding nothing," are "eyeless, and so terrible" (TtL 203). With the Ramsays gone and the house empty, one might well ask, "What power could now prevent the fertility, the insensibility of nature? Mrs. McNab's dream of a lady, of a child, of a plate of milk soup?" (TtL 207). Faint memories of Mrs. Ramsay in the mind of the cleaning woman seem incapable of stemming the flow of decay. "Only the Lighthouse beam entered the rooms for a moment, sent its sudden stare over bed and wall in the darkness of winter" (TtL 207–8). And what can a beam of light do?

Yet even in the voice of hopelessness there is hope. For that memory called up by Mrs. McNab (who is designated "the voice of the . . . principle of life, & its power to persist" [TtLd 211] in the draft of the novel) reminds us of a particular power in that Lighthouse ray. She sees Mrs. Ramsay "stooping over her flowers; and faint and flickering, like a yellow beam [the simile is an addition to the draft] or the circle at the end of a telescope, a lady in a gray cloak, stooping over her flowers, went wandering over the bedroom wall, up the dressing-table, across the wash-stand [more lighthouse-beam imagery added after the draft] as Mrs. McNab hobbled and ambled, dusting, straightening" (TtL 205). This imagery harks back to "The Window," where Mrs. Ramsay, "sitting and looking, with her work in her hands . . . became the thing she looked at—that light [from the Lighthouse], for example" (TtL 97), so that when *only* the Lighthouse beam enters the house (TtL 207), we suspect that Mrs. Ramsay is still present, a strange "only" indeed. In fact much of the change that washes over the surface of the Hebrides world during the ten years between "The Window" and "The Lighthouse" is less dramatic than first appears. When Mrs. McNab and Mrs. Bast shake their heads and say "seeds might be sent, but who should say if they were ever planted? They'd find it changed" (TtL 212), we remember that Mrs. Ramsay in "The Window" had

these same doubts about plants sent down (TtL 101): in some ways nothing has changed at all.

Though as "Time Passes" unrolls before us we come to rest in the assurance that continuity is as much a part of life as change, we can enjoy the games Woolf plays with us to suggest a danger we know will be overcome. For example, at one point she offers the loss of vision of her dreamer as though it were the final word and only rescues it by a mark of punctuation. "Did Nature supplement what man advanced?" she asks; and then seems to answer, "That dream, of sharing, completing, of finding in solitude on the beach an answer, was then but a reflection in a mirror, and the mirror itself was but the surface glassiness which forms in quiescence when the nobler powers sleep beneath?" (TtL 201–2). Only with the question mark do we realize that we should have been reading this sentence as a doubtful hypothesis and not a clear assertion. (Woolf originally began the sentence: "Was it . . ." and so denied us the surprise.)

Her most elaborate trick of stylistic illusion comes at the point when she announces the moment when decay might triumph and order dissolve forever. Using a contrary-to-fact construction, built up of conditional auxiliary verbs, often implied, with a series of past participles, she allows us to visualize the destruction that these verb forms themselves assure us never took place:

> For now had come that moment, that hesitation when dawn trembles and night pauses, when if a feather alight in the scale it will be weighed down. One feather, and the house, sinking, falling, would have turned and pitched downwards to the depths of darkness. In the ruined room, picnickers would have lit their kettles; lovers sought shelter there, lying on the bare boards; and the shepherd stored his dinner on the bricks, and the tramp slept with his coat round him to ward off the cold. Then the roof would have fallen; briars and hemlocks would have blotted out path, step, and window; would have grown, unequally but lustily over the mound, until some trespasser, losing his way, could have told only by a red-hot poker among the nettles, or a scrap of china in the hemlock, that here once some one had lived; there had been a house.

> If the feather had fallen, if it had tipped the scale downwards, the whole house would have plunged to the depths to lie upon the sands of oblivion. But there was a force working (TtL 208–9).

The "would have," from the very outset, leads us to expect the "but." Yet the series of past participles—"sought," "stored," "slept"—with the "would have" only implied, begin to sound like straight past tense until we almost believe that lovers, shepherds, and tramps actually invaded a now ruined house. But Woolf quickly reinstates the auxiliary verb, insists on it, in fact, until we find ourselves holding our breaths in anticipation of the saving "but." Mrs. Ramsay pictured herself as a drowned sailor, sinking to the floor of the sea, but in becoming one with the Lighthouse beam, she assures herself of immortality. So, in the same images, the possibility of the house's sinking to lie on the sands of oblivion is also offered, only to be confuted.

By the end of "Time Passes," then, we are not surprised that Virginia Woolf has chosen to give us her final image of the dreamer in a state of assurance and joy. "Then indeed peace had come. Messages of peace breathed from the sea to the shore. Never to break its sleep any more, to lull it rather more deeply to rest, and whatever the dreamers dreamt holily, dreamt wisely, to confirm" (TtL 213). We may know that even this vision cannot last, for the rise and fall of moments of being are what create the permanence of the pattern, but to pause at the rise is to confirm the hope of stability and order that the pattern images forth.

"The Lighthouse"

"Time Passes" may have established both the fact of change and the possibility of permanence in its symbolic, poetic form. But except for Mrs. McNab, and Lily at the very end of the section, the human characters of the novel have not been exposed to the pattern we have been offered. The pains and turning points of their lives have been set off from the rest, contained in the little, bracketed passages that are

wrapped in natural imagery, like the boar's skull in Mrs. Ramsay's shawl. It is not until they return to their summer home and reconcile, through memory and action, the past with the present that they can realize the vision implied by "Time Passes."

If one were to choose an epigraph for "The Lighthouse" portion of this novel, one might do well to select this passage from Woolf's own "A Sketch of the Past": "For the present when backed by the past is a thousand times deeper than the present when it presses so close that you can feel nothing else, when the film on the camera reaches only the eye. But to feel the present sliding over the depths of the past, peace is necessary" (MoB 98). In the final section of *To the Lighthouse*, all the characters are engaged in this exercise of marrying their present to their past, attempting to achieve the depth Woolf speaks of. For each, the peace needed to consummate this marriage comes gradually; but from the very outset, some of the stillness attained in "Time Passes" seems to have crept into their lives, allowing them to recognize the symbolic possibilities inherent in their return to the old seaside home. Even the question that opens the section rings with the incantatory note that warned of the presence of universals in "Time Passes": "What does it mean then, what can it all mean?" (TtL 217). And language continues to vibrate with more than its ordinary significance as the family and friends prepare for the day ahead. As Lily observes, "this morning everything seemed so extraordinarily queer that a question like Nancy's—What does one send to the Lighthouse?—opened doors in one's mind that went banging and swinging to and fro and made one keep asking, in a stupified gape, What does one send? What does one do? Why is one sitting here, after all?" (TtL 218). Then, "like everything else this strange morning . . . words became symbols, wrote themselves all over the grey-green walls. If only she could put them together, she felt, write them out in some sentence, then she would have got at the truth of things" (TtL 219).

An attempt to find the meaning of life was implicit in Mr. Ramsay's search for Z, Mrs. Ramsay's dinner, Mr. Bankes's science, and Lily's struggle with her painting in "The Window." Now it has become explicit in Lily's mind after all these years. But the problem has re-

mained essentially the same—how to bring the separated elements of life into harmony—although the need to reconcile past to future has been joined to the other needs for unity. So the main characters return to the issues they faced ten years before. For James "[t]here was this expedition—they were going to the Lighthouse. . . . They should have gone already" (TtL 217). When he was seven, this trip had its own special radiance. Now he must make a number of difficult connections in his mind before that radiance can be rekindled; but the voyage is finally at hand. Significantly, too, it has become a voyage for Mr. Ramsay as well, which he is making in honor and in memory of his wife (TtL 226). It will be no easier for him than for James to make the trip in the proper spirit, but "[t]here was no helping Mr. Ramsay on the journey he was going" (TtL 230). Each person must embark, and arrive, or founder, alone.

As she stands wondering "What does one send to the Lighthouse?" Lily begins to associate that question with another sort of journey between points, that ventured upon by the artist, who needs to make her own connections: "Going to the Lighthouse. . . . Perished. Alone. The grey-green light on the wall opposite. The empty places. Such were some of the parts, but how bring them together?" (TtL 220). Then she remembers her painting, unfinished after all these years. Somehow it should include in it the question about the Lighthouse, and Mr. Ramsay's loneliness, and Mrs. Ramsay's death, contained as they are in the wall, the hedge, the tree. Finally, after the long passage of time, Lily feels "as if the solution had come to her: she knew now what she wanted to do" (TtL 221). So she, too, sets sail, figuratively, with her canvas and paints. And all the morning, as she works, her progress seems tied to that of the little boat in which Mr. Ramsay, Cam, and James are making their way toward the Lighthouse.

When Cam and James start down the path toward the beach from which they will embark, they carry with them the anger James originally felt for his father, now refined, slightly, into a silent rebellion against the authority of the Victorian Age. Unwilling to accept passively their father's demand that they take part in his symbolic mourn-

ing, "they vowed, in silence, as they walked, to stand by each other and carry out the great compact—to resist tyranny to the death" (TtL 243), to reject the roles assigned to them by the representative of the past.

Cam, in her first appearance in "The Window," was not easy to define. Tomboyish, off in her own world and oblivious even to her mother, she tore around the gardens, refusing to play the sweet little girl who should give Mr. Bankes a flower. In the nursery she showed signs of sharing her mother's sensitivity, but her identity seemed as yet unformed. In constructing the older Cam for "The Lighthouse," Woolf initially made her something of an assertive rationalist who does not vaguely murmur bits of the poetry her father loves but "sitting upright said over to herself the whole poem as far as she knew it" (TtLd 317), who explores with conscious intellectualism questions about the evolution of the world, the ancient civilizations of Egyptians, the Byzantine Empire (TtLd 320). In short, she appears to be the modern thinking woman, a chip off her father's block rather than her mother's. But by the time Woolf had completed this last section of the novel, Cam had been softened so that she could contain elements of her mother as well as her father.

The associations with Mrs. Ramsay are introduced subtly—for example, Mr. Ramsay sends Cam back for a cloak, which her mother wore, instead of the coat of the first draft. Then, in moments of growing peace as the voyage gets further and further under way and the solid land, symbol of her father, grows dim with distance, Cam begins to feel as her mother felt, admiring her father for his courage and his adventurousness, his masculine qualities. Like her mother, too, who felt sustained by the masculine intelligence, she feels safe "when she crept in from the garden, and took a book down, and the old gentleman, lowering the paper suddenly, said something very brief over the top of it about the character of Napoleon" (TtL 283). On her imaginary wanderings as she trails her hand in the sea, she is wrapped in her mother's clothing, feeling that "in the green light a change came over one's entire mind and one's body shone half transparent enveloped in a green cloak" (TtL 272). And just as her mother became a

fountain for her father and traveled to the Mediterranean in her invisible journeys, so Cam feels a "fountain of joy" showering itself down "here and there on the dark, the slumbrous shapes in her mind; shapes of a world not realised but turning in their darkness, catching here and there, a spark of light; Greece, Rome, Constantinople" (TtL 280–81).

Yet Cam, for all that she begins to experience the emotions of a woman, does not lose all her masculine traits and slip back into being the Victorian handmaid of the male. She may wish to send her father the sort of indirect signal of her love that her mother used so often (TtL 252), but she holds fast to her compact with her brother and remains silent, though freed from her earlier hostility toward Mr. Ramsay. For she is rather like him, in her way. Like him she tells herself "a story of adventure about escaping from a sinking ship" (TtL 280); and like him she quotes Cowper's poetry. But she quotes it with the unconscious appreciation with which her mother approached Shakespeare, murmuring "dreamily, half asleep, how we perished each alone" (TtL 284), thus combining aspects of both parents in one breath. For unity, an androgynous vision, is what Virginia Woolf is aiming at. She suggested in the opening pages of her novel that one way it may be attained is for two people to pour their natures into the ewer of a child to create a greater union than they could achieve themselves. Thus Cam, like her brother, must be able to see with the eyes of both her parents.

We already know James as a combination of his mother's vision and his father's rationality from his appearance at the outset of the novel. Now, as the voyage to the Lighthouse begins, he is ready to discover both halves of his nature and to see that he is more like his father than he imagines, with his uncompromising severity and dedication to abstract principles. The object of his wrath at this point is still Mr. Ramsay, although James is beginning to understand that "it was not him, that old man reading, whom he wanted to kill, but it was the thing that descended on him . . . tyranny, despotism, he called it" (TtL 273–74). During the course of the brief sail, this separation between his father and his father's occasional despotism grows clearer

to James. Little by little he realizes that he and his father are kindred spirits, that "there was a waste of snow and rock very lonely and austere; and there he had come to feel, quite often lately, when his father said something or did something which surprised the others, there were two pairs of footprints only; his own and his father's. They alone knew each other" (TtL 274–75). Once he is able to acknowledge his father in himself, James is ready for that moment when the two sorts of reality, that perceived by his mother and that perceived by his father, come together like the two images of a stereopticon to create a three-dimensional whole.

To complete his journey, both literal and figurative, Woolf offers the Lighthouse itself for this image of unity. The boat draws near its destination, and as the Lighthouse comes into view, James sets his memory against what lies before him:

> The Lighthouse was then a silvery, misty-looking tower with a yellow eye, that opened suddenly, and softly in the evening. Now—
> James looked at the Lighthouse. He could see the white-washed rocks; the tower, stark and straight; he could see that it was barred with black and white; he could see windows in it; he could even see washing spread on the rocks to dry. So that was the Lighthouse, was it?
> No, the other was also the Lighthouse. For nothing was simply one thing. The other Lighthouse was true too. (TtL 276–77)

The refrigerator is indeed endowed with heavenly bliss. The long stroke of the Lighthouse, which is Mrs. Ramsay's stroke, has been joined to the upright channel marker that is Mr. Ramsay. Accepting both, James can now relax in his likeness to his father: "'We are driving before a gale—we must sink,' he began saying to himself, half aloud, exactly as his father said it" (TtL 302). So he and Cam end by telling themselves the same story, combining courage and imagination. For them the journey is over, the union achieved.

The last member of this expedition, Mr. Ramsay, has in his way, already entered "that final phase . . . when it seemed as if he had shed worries and ambitions, and the hope of sympathy and the desire for

praise" (TtL 233). For in going to the Lighthouse, making the trip he had once declared impossible while his wife hoped for its completion, he has drawn closer to her, acknowledging the justice of her vision in something of the indirect way in which she affirmed his in the last lines of "The Window." In this new venturing into his wife's realm, he can, to his children's amazement, let go of his self-pity, accepting the death of others when he hears about it without turning the tragedy to make it reflect on himself (TtL 306). In the past he may have missed Prue's beauty, but on this day, with his new vision, he can see, and give credit to, the achievement of his own son, exclaiming: "'Well done!' James had steered them like a born sailor" (TtL 306). So as he arrives at the Lighthouse and springs up onto the rocks, he maintains his intensity and integrity even while completing the journey he could not have made in the proper spirit at the opening of the book. His children see him, now, for what he is and focus on him without rancor, having been brought into harmony with him at last: "He rose and stood in the bow of the boat, very straight and tall, for all the world, James thought, as if he were saying, 'There is no God,' and Cam thought, as if he were leaping into space, and they both rose to follow him" (TtL 308).

If Cam, James, and Mr. Ramsay, on this September morning, complete a journey that in some ways has taken ten years, Lily Briscoe has just as far to go. For although she will not change her surroundings, trade beach for sea for Lighthouse rock, she must bring her judgments out of the past and into the present. She must see Mr. Ramsay and Mrs. Ramsay anew, with the perspective time has given her, and in the process complete a painting that can escape the passage of time by gathering all time into it.

Before she can even set up her easel properly or manage her brushes, she is confronted with her first call to change in the person of Mr. Ramsay. He presents a particular challenge because he represents the insistent demands of the Victorian male that seem to deny her own sort of womanhood, that of the artist, and require of her the sort embodied by Mrs. Ramsay. At first Lily feels her own inadequacy as Mr. Ramsay stands before her, insisting on her sympathy. "A

woman," she thinks, "she had provoked this horror; a woman, she should have known how to deal with it. It was immensely to her discredit, sexually, to stand there dumb." He pours his sorrow at her feet, "and all she did, miserable sinner that she was, was to draw her skirts a little closer round her ankles, lest she should get wet" (TtL 228). What makes it so difficult for her to slip into the role requested is not only that she is attempting to define a different role for herself, but also that Mr. Ramsay stands for the voice that causes her to doubt the possibility of living out such a new role. When she takes up her brushes, "she heard some voice saying she couldn't paint, saying she couldn't create, as if she were caught up in one of those habitual currents in which after a certain time experience forms in the mind, so that one repeats words without being aware an̄ ᴐnger who originally spoke them" (TtL 237). Of course it was Charles Tansley who was forever chanting, "Women can't write! Women can't paint!" But Lily has absorbed his message, hearing it indirectly from any man who confronts her and echoing it in her own thought. Thus Lily is not sure enough of her painterly self to reach out from it to Mr. Ramsay. Men cannot take women's painting seriously, she assumes, momentarily forgetting Mr. Bankes. So Mr. Ramsay makes her *play* at painting when she wants painting to be the most sacred thing in her life. How can she dare to make compromises for him?

The possibility of seeing Mr. Ramsay as other than threatening to her sense of self, of being able to give him the support he needs, at first seems beyond her powers, but Lily is more like Mrs. Ramsay than she thinks or is aware of. As she stands with Mr. Ramsay sighing before her, she chances to look down at his boots, and, in what seems to her a tangential thought at best, comments to herself:

> Remarkable boots they were too ... sculptured; colossal; like everything that Mr. Ramsay wore, from his frayed tie to his half-buttoned waistcoat, his own indisputably. She could see them walking to his room of their own accord, expressive in his absence of pathos, surliness, ill-temper, charm.
> "What beautiful boots!" she exclaimed. (TtL 228–29)

Being unaware of what she has done, Lily assumes that Mr. Ramsay will explode with fury at her irrelevant remark, but instead he is transformed into a cheerful, kindly man, satisfied by her offering. She has answered his demand indirectly, just as Mrs. Ramsay once answered indirectly his demand that she say "I love you." Mrs. Ramsay chose the Lighthouse trip as the proper subject with which to declare her affection, an appropriate symbol on that particular day. And Lily has selected her own subject equally wisely. For Mr. Ramsay's boots are his passion, his pride, a symbol of his practicality and ingenuity and of his moor-striding self (TtL 156–57). To praise them is to praise him. Since Lily herself sees them as representing the whole of Mr. Ramsay's personality, she unconsciously knows the import of her praise. In effect she is saying, "what a beautiful person you are, after all, Mr. Ramsay!" and he hears her accurately.

All this about boots is an addition to the draft, one effective in connecting Lily to both Mr. and Mrs. Ramsay. For Lily is reduced to tears when Mr. Ramsay stoops to tie her shoes just as Mrs. Ramsay, in one of her most moving moments with her husband, thinks, "She was not good enough to tie his shoe strings" (TtL 51) when he has just humbled himself before her. Having joined Mrs. Ramsay without giving up any of her own independence, Lily has attained a sense of the range of her own abilities, a greater confidence in herself, realizing that a woman may be an artist and still appreciate and soothe a man. So whereas she initially saw the Lighthouse trip from the point of view of James and blamed Mr. Ramsay for coercing the spirits of his children, now she sees it more as Mrs. Ramsay would have, as a chance for connection, and feels annoyed with Cam and James for sulking and disappointing their father. She wants, as they will want, to make an offering to him. For he has ceased to threaten her sense of self but has in his way done homage to it. In fact she has begun to see herself as he sees himself, standing out "on a narrow plank, perfectly alone, over the sea" (TtL 256). His plank is philosophy; hers is painting; but with his practical boots and her sensible shoes they stand, alone, together.

To give Mr. Ramsay back to himself without compromising her

own values is no easy matter for Lily. She must see him in perspective and then respond to him in a way that will honor him but protect herself, as Mrs. Ramsay did in the last scene of "The Window." But to gain a new vision of Mr. Ramsay is far easier for Lily than to see Mrs. Ramsay whole, for Mrs. Ramsay, in her lifetime, was in some ways both the most fruitful and the most dangerous influence Lily knew.

As Lily works through her memories of Mrs. Ramsay, she first deals with those that threaten her, memories of Mrs. Ramsay as matchmaker. "What was this mania of hers for marriage?" (TtL 261) Lily wonders as she paints, going on to speculate that she, had Mrs. Ramsay lived, might have ended up married to William Bankes. "Mrs. Ramsay had planned it. Perhaps, had she lived, she would have compelled it" (TtL 261), and marriage, as Lily sees it, would have put an end to her painting. "She had only escaped by the skin of her teeth" (TtL 262), by relying first of all on her vision of the tree moved to the middle, of a painting that would create a satisfying balance in her life, but second on the diminishing of Mrs. Ramsay's influence through death. With Mrs. Ramsay at a distance, Lily can stand up to her and can afford to pay "tribute to the astonishing power that Mrs. Ramsay had over one" (TtL 262).

To assure herself that Mrs. Ramsay's vision for her was unwise, Lily calls up a number of witnesses. First, her quite satisfactory relationship with William Bankes as it is, not as his wife but as an affectionate friend. Second, the failure of Paul and Minta's marriage, in which Mrs. Ramsay had placed so much hope. Third, the general changes wrought by time. All these serve to detach Lily from Mrs. Ramsay's power until Lily imagines saying to her: "It has all gone against your wishes. They're happy like that; I'm happy like this. Life has changed completely. At that all her being, even her beauty, became for a moment, dusty and out of date" (TtL 260). Having cut the ties that bound her to Mrs. Ramsay, Lily feels liberated. But the fact of the matter is that Mrs. Ramsay's absence affects Lily's painting perhaps even more than her presence. "It must have altered the design a good deal," Lily thinks, "when she was sitting on the step with James. There

must have been a shadow" (TtL 239). What Lily, then, must do, having declared her independence of Mrs. Ramsay, is to reclaim her, bring her back into the picture. For she has not really gone. Her being is not dusty and out of date. As Woolf said of "The Lighthouse" section when outlining it: "The dominating impression is to be of Mrs. R's character" (TtLd 2), for she is very much a part of the Lighthouse world still. When Lily can rediscover the essential power of Mrs. Ramsay without seeing it as a threat, she can finish her painting.

The fact that Mrs. Ramsay can still affect her emotionally comes pouring down on Lily not long after her declaration of independence and allows her to see that the past is always part of the present, often in a shockingly unexpected way. "Was there no safety?" she thinks, upon suddenly feeling with great pain the loss of her old friend, "No learning by heart the ways of the world? No guide, no shelter, but all was miracle, and leaping from the pinnacle of a tower into the air? Could it be, even for elderly people, that this was life?—startling, unexpected, unknown?" (TtL 268). From discovering the sorrow of the past very much alive in the present, Lily moves to the point of realizing that the cause of that sorrow, Mrs. Ramsay herself, may somehow be equally alive, for she feels the anguish subside and in its place, "mysteriously, a sense of some one there, of Mrs. Ramsay, relieved for a moment of the weight that the world had put on her, staying lightly by her side" (TtL 269). This resurrected Mrs. Ramsay is not seen, only felt, but it is clear that she is different from the former Mrs. Ramsay, relieved of the daily burden she carried as a wife and mother. She appears in Lily's imagination as a symbolic figure—herself, "stepping with her usual quickness," but mythological as well, "raising to her forehead a wreath of white flowers" (TtL 269–70), calling to mind the imagery Charles Tansley used of her when she was exerting most strongly over him the force of her beauty and feminine creativity.

With this new vision of Mrs. Ramsay, Lily begins to realize her friend's complexity, to see her in three dimensions, as an artist must before choosing out the essential qualities from which to make a painting. "One wanted fifty pairs of eyes to see with, she reflected. Fifty pairs of eyes were not enough to get round that one woman with"

(TtL 294). The wholeness of Mrs. Ramsay, which Lily is finally able to see, reveals her not merely as a charismatic Victorian woman, compelling her friends and daughters into marriage, but as an artist in her own right, one who, in her own medium, could bring together opposing masses (say Charles Tansley and Lily herself) and make of them a union as effective in its power as a work of art. So Lily begins to understand as she calls up a moment of being from her past, created by Mrs. Ramsay:

> When she thought of herself and Charles throwing ducks and drakes and of the whole scene on the beach, it seemed to depend somehow upon Mrs. Ramsay sitting under the rock, with a pad on her knee, writing letters. . . . But what a power was in the human soul! she thought. That woman sitting there writing under the rock resolved everything into simplicity; made these angers, irritations fall off like old rags; she brought together this and that and then this, and so made out of that miserable silliness and spite (she and Charles squabbling, sparring, had been silly and spiteful) something . . . which survived, after all these years complete, so that she dipped into it to re-fashion her memory of him, and there it stayed in the mind affecting one almost like a work of art. (TtL 239–40)

Lily, under the influence of the art that Mrs. Ramsay has created, addresses the question that Woolf designated as the proper one for the woman who wants to be an artist to ask: "What is the meaning of life?" And the answer she is granted, which Woolf describes in her discussion of moments of being and embodies in the pattern of transcendent moments, like this one, in her book, is this:

> The great revelation had never come. The great revelation perhaps never did come. Instead there were little daily miracles, illuminations, matches struck unexpectedly in the dark; here was one. This, that, and the other; herself and Charles Tansley and the breaking wave; Mrs. Ramsay bringing them together; Mrs. Ramsay saying, "Life stand still here"; Mrs. Ramsay making of the moment something permanent (as in another sphere Lily herself tried to make of the moment something permanent)—this was of the nature of a

revelation. In the midst of chaos there was shape; this eternal pass-
ing and flowing ... was struck into stability. Life stand still here,
Mrs. Ramsay said. "Mrs. Ramsay! Mrs. Ramsay!" she repeated.
She owed it all to her. (TtL 240–41)

At this point Lily understands her genuine kinship with Mrs. Ram-
say. They are both artists, realizing moments of being for those
around them who might otherwise miss "the thing that en-
dures."

Once the sisterhood of the Victorian matron and the modern art-
ist becomes clear, the pattern of connections Woolf has quietly made
between them throughout the book is explained. Mrs. Ramsay sees
life as her opponent in a battle "and she was always trying to get the
better of it, as it was of her" (TtL 92). Lily feels the same tension in
her struggle to master form, which "roused one to perpetual combat,
challenged one to a fight in which one was bound to be worsted" (TtL
236). Both warriors, Lily and Mrs. Ramsay, oddly enough, experience
their moments of respite and peace in the imagery of churches. As a
wedge-shaped core of darkness, Mrs. Ramsay feels herself entering a
church in Rome, and in the calm of the dinner party she hears the
voices around her "as if they were voices in a service in a cathedral
(TtL 165–66). Then Lily, as her painting begins to take form, "felt as
if a door had opened, and one went in and stood gazing silently about
in a high cathedral-like place, very dark, very solemn" (TtL 255). Both
suffer from the inadequacy of language, feel that always "[w]ords flut-
tered sideways and struck the object inches too low" (TtL 265). But if
words fail, their own force of creativity does not, and the imagery
Woolf uses to describe it is the same for each. Mrs. Ramsay, in infusing
her husband with new creative vitality, rises up like a fountain, a col-
umn of spray, and rains energy down around her. Lily, in the imper-
sonality of artistic creation, finds inspiration rising up in her "like a
fountain spurting over that glaring, hideously difficult white space,
while she modelled it with greens and blues" (TtL 238).

Before she realized that Mrs. Ramsay and she were working to-
ward the same ends, Lily had felt a danger in Mrs. Ramsay's fervent

belief in love, for she assumed that love belonged only in marriage, or at least in a relationship between the sexes. Thus if marriage were not for her, love could not be hers either. But once she sees Mrs. Ramsay as an artist, Lily is able not only to admit her love for William Bankes, but also to recognize herself as another, special sort of lover; for she sees that "[l]ove had a thousand shapes. There might be lovers whose gift it was to choose out the elements of things and place them together and so, giving them a wholeness not theirs in life, make of some scene, or meeting of people (all now gone and separate), one of those globed compacted things over which thought lingers, and love plays" (TtL 286). What was hinted at in "The Window" has been established in "The Lighthouse": love and art are both creative forces that unite the most disparate elements of life. The woman's role in the modern age is simply another form of the woman's role in the Victorian—the maker of wholeness, harmony, and permanence.

All that remains is for Lily to achieve in her painting what Mrs. Ramsay achieved on the beach. And she is prepared to do it, for the void left in the composition by the absence of Mrs. Ramsay has been filled. Mrs. Ramsay, newly understood, has returned, and the "odd-shaped triangular shadow" is back on the step (TtL 299). Now comes the moment to bring together the opposites for balance in her picture, to see as a man and as a woman. "One must hold the scene—so—," she thinks, "in a vise and let nothing come in and spoil it. One wanted, she thought, dipping her brush deliberately, to be on a level with or-dinary experience, to feel simply that's a chair, that's a table, and yet at the same time, It's a miracle, it's an ecstasy" (TtL 299–300). We have come full circle to the refrigerator fringed with joy, only now it seems to be Mr. Ramsay's kitchen table radiant with Mrs. Ramsay's sense of ecstasy. Mrs. Ramsay is here, as Lily reaches to bring both masses together: she sits there "quite simply, in the chair, flicked her needles to and fro, knitted her reddish-brown stocking, cast her shadow on the step" (TtL 300).[41] But the painting is not of her alone. It is meant to draw the ends of the world together. So Lily hurries to the edge of the lawn and looks for Mr. Ramsay's boat, for "[s]he wanted him" (TtL 300).

To complete her own arrangement of the mass on the right with the mass on the left, Woolf herself pauses to seek out Mr. Ramsay; for she needs to present the last few pages so that the reader may visualize Mr. Ramsay stepping onto the rock of the Lighthouse just as Lily draws "a line there, in the centre" (TtL 310). In this last line, the opposing elements of the novel are brought finally into balance—Woolf's past and the present in which she was writing, the Victorian view of women and the modern, the masculine and feminine in a vision of androgyny, love and art. As she wrote the final words, Woolf could well exclaim, even as she realized that the moment of permanence she had created was bound to fall back into the blur of life's cotton wool, "I have had my vision" (TtL 310).

Notes

1. *Virginia Woolf: The Critical Heritage,* ed. Robin Majumdar and Allen McLaurin (London and Boston: Routledge & Kegan Paul, 1975), 49.

2. *The Diary of Virginia Woolf,* vol. 3, 1925–1930, ed. Anne Olivier Bell (London: Hogarth Press, 1980), 18.

3. Ibid., 36.

4. Virginia Woolf, *Roger Fry: A Biography* (New York and London: Harcourt Brace Jovanovich, 1968), 172.

5. *The Letters of Virginia Woolf,* vol. 3, 1923–1928, ed. Nigel Nicolson and Joanne Trautmann (New York and London: Harcourt Brace Jovanovich, 1977), 247.

6. To those familiar with Roger Fry's "Artist's Vision," this passage carries extra force, for the language Fry uses to describe the creative vision in that essay is surprisingly like that which Woolf uses to describe James—"Almost any turn in the kaleidoscope of nature may set up in the artist this detached and impassioned vision, and, as he contemplates the particular field of vision the (aesthetically) drastic and accidental conjunction of forms and colours begins to crystallise into a harmony. . . . In such circumstances the greatest object of art becomes of no more significance than any casual piece of matter; a man's head is no more and no less important than a pumpkin [or, say, a refrigerator] or, rather these things may be so or not according to the rhythm that obsesses the artist and crystallises his vision" (V&D 249, 250). We might then begin to suspect some real weight behind Mrs. Ramsay's seemingly facile remark about her son: "What a delight it would be to her should he turn out a great artist; and why should he not. He had a splendid forehead" (TtL 49). James may be able, with his own eyes, to unite his father's rationality, represented by his high forehead, with his mother's impassioned vision, and see with the artist's uniting eye.

7. *Diary,* 3:49.

8. Quentin Bell, *Virginia Woolf: A Biography* (New York: Harcourt Brace Jovanovich, 1972), 128.

9. Noel Annan, *Leslie Stephen: The Godless Victorian* (New York: Random House, 1984), 92.

10. Leslie Stephen, *Sir Leslie Stephen's Mausoleum Book* (Oxford: Clarendon Press, 1977), 93.

11. Bell, *Virginia Woolf*, 10.

12. Annan, *Leslie Stephen*, 109.

13. Ibid., 33.

14. *Mausoleum Book*, 95.

15. Ibid., 82.

16. Ibid., 75.

17. Ibid., 95.

18. Ibid., 90.

19. Ibid., 79.

20. Bell, *Virginia Woolf*, 32.

21. Woolf, *Roger Fry*, 236.

22. Virginia Woolf, *Moments of Being: Unpublished Autobiographical Writings*, ed. Jeanne Schulkind (New York and London: Harcourt Brace Jovanovich, 1976), 135.

23. Annan, *Leslie Stephen*, 110.

24. Ibid.

25. Recently several valuable articles have appeared, discussing Woolf's indebtedness to her literary ancestresses (see Bibliography).

26. Woolf, *Roger Fry*, 227.

27. Clive Bell, *Art* (New York: Capricorn Books, 1958), 24. *The good* was a term that Bloomsbury accepted as undefinable, after their philosopher mentor, G. E. Moore, spent most of his *Principia Ethica* proving it incapable of definition.

28. Bell, *Art*, 27.

29. *Letters*, 3:247.

30. Bell, *Art*, 17.

31. Ibid., 46, 62–63.

32. Roger Fry, *Transformations: Critical and Speculative Essays on Art* (Garden City, N.Y.: Doubleday Anchor, 1956), 11.

33. Ibid., 9.

34. Bell, *Art*, 107.

35. Ibid., 110.

36. Woolf, *Roger Fry*, 245.

37. *Letters*, 3:385.

38. *Diary,* 3:102.

39. Ibid.

40. Virginia Woolf herself is eerily present in this scene since her child-hood nickname was "the goat" and her mother's last words to her: "Hold yourself straight, little goat!"

41. The draft makes Mrs. Ramsay less literally present, for there "the white shape was ~~extremely~~ ~~like~~ chair as it happened was exactly as she used to sit in it" (TtLd 348).

Bibliography

Primary Sources

Bell, Anne Olivier, ed. *The Diary of Virginia Woolf*. Vol. 3, *1925–1930*. London: Hogarth Press, 1980.

Bell, Clive. *Art*. New York: Capricorn Books, 1958.

Fry, Roger. *Transformations: Critical and Speculative Essays on Art*. Garden City, N.Y.: Doubleday Anchor Books, 1956.

———. *Vision and Design*. Cleveland and New York: World Publishing Co., 1969.

Nicolson, Nigel, and Trautmann, Joanne, eds. *The Letters of Virginia Woolf*. Vol. 3, *1923–1928*. New York and London: Harcourt Brace Jovanovich, 1977.

Stephen, Leslie. *Sir Leslie Stephen's Mausoleum Book*. Introduction by Alan Bell. Oxford: Clarendon Press, 1977.

Woolf, Virginia. *Collected Essays*. Vols. 1–4. Edited by Leonard Woolf. 1966–67. Reprint. New York: Harcourt, Brace & World, 1967.

———. *Moments of Being: Unpublished Autobiographical Writings*. Edited by Jeanne Shulkind. 1976. Rev. ed. New York and London: Harcourt Brace Jovanovich, 1985.

———. *Roger Fry: A Biography*. 1940. Reprint. New York and London: Harcourt Brace Jovanovich, 1968.

———. *A Room of One's Own*. 1929. Reprint. New York and London: Harcourt Brace Jovanovich, 1957.

———. *To the Lighthouse*. 1927. Reprint. New York and London: Harcourt Brace Jovanovich, 1955.

———. *To the Lighthouse: The Original Holograph Draft*. Transcribed and edited by Susan Dick. Toronto and Buffalo: University of Toronto Press, 1982.

Secondary Sources

Annan, Noel. *Leslie Stephen: The Godless Victorian*. New York: Random House, 1984. A fine biography of Virginia Woolf's father.

Auerbach, Erich. *Mimesis: The Representation of Reality in Western Literature*. Garden City, N.Y.: Doubleday Anchor Books, 1957. Contains an excellent chapter analyzing Woolf's technique in *To the Lighthouse*.

Bazin, Nancy Topping. *Virginia Woolf and the Androgynous Vision*. New Brunswick, N.J.: Rutgers University Press, 1973. A general work, emphasizing Woolf's aesthetics as embodied in the concept of androgyny.

Bell, Quentin. *Virginia Woolf: A Biography*. New York: Harcourt Brace Jovanovich, 1972. The standard Woolf biography.

Bennett, Joan. *Virginia Woolf: Her Art as a Novelist*. Cambridge: Cambridge University Press, 1945. A good early study of Woolf's novels.

Blackstone, Bernard. *Virginia Woolf: A Commentary*. London: Hogarth Press, 1949. Early critical look at Woolf as a mystic.

Church, Margaret. *Time and Reality: Studies in Contemporary Fiction*. Chapel Hill: University of North Carolina Press, 1963. Contains a useful section on Woolf's representation of time.

Clements, Patricia, and Grundy, Isobel, eds., *Virginia Woolf: New Critical Essays*. London and Totowa, N.J.: Vision Press and Barnes & Noble, 1983. A diverse collection of helpful essays, a number of them setting Woolf's work in relation to other modern writers.

Daiches, David. *Virginia Woolf*. New York: New Directions, 1963. Sets Woolf's work in its contemporary context.

DiBattista, Maria. *Virginia Woolf's Major Novels: The Fables of Anon*. New Haven and London: Yale University Press, 1980. A well-written study with a chapter on *To the Lighthouse* that offers a psychoanalytic reading of the novel.

Fleishman, Avrom. *Virginia Woolf: A Critical Reading*. Baltimore and London: Johns Hopkins University Press, 1975. Useful close readings of the novels, emphasizing the symbolic function of the imagery.

Ginsberg, Elaine K., and Gottlieb, Laura Moss, eds. *Virginia Woolf: Centennial Essays*. Troy, N.Y.: Whitson Publishing Co., 1983. A collection demonstrating the range of approaches in contemporary Woolf criticism, including several focused on *To the Lighthouse*.

Guiguet, Jean. *Virginia Woolf and Her Works*. Translated by Jean Stewart. New York: Harcourt, Brace, 1966. One of the more thorough early studies of Woolf's work.

Hafley, James. *The Glass Roof: Virginia Woolf as a Novelist*. Berkeley: Uni-

Bibliography

versity of California Press, 1954. Particularly interesting on Woolf's presentation of time.

Heilbrun, Carolyn G. *Toward a Recognition of Androgyny.* New York: Knopf, 1973. A general book on the subject of androgyny with useful reference to Woolf.

Johnstone, J. K. *The Bloomsbury Group: A Study of E. M. Forster, Lytton Strachey, Virginia Woolf, and Their Circle.* New York: Noonday Press, 1954. Useful in setting Woolf in the philosophical and aesthetic context of her close associates.

Leaska, Mitchell A. *Virginia Woolf's Lighthouse: A Study in Critical Method.* New York: Columbia University Press, 1970. Valuable in its detailed treatment of Woolf's complex manipulation of point-of-view but occasionally misleading as a result of misattributed quotation.

Love, Jean O. *Virginia Woolf: Sources of Madness and Art.* Berkeley: University of California Press, 1977. A topical biography addressing the issue of Woolf's madness.

McLaurin, Allen. *Virginia Woolf: The Echoes Enslaved.* Cambridge: Cambridge University Press, 1973. Of particular interest to those who wish to pursue Woolf's connections to Roger Fry.

Majumdar, Robin, and McLaurin, Allen, eds. *Virginia Woolf: The Critical Heritage.* London and Boston: Routledge & Kegan Paul, 1975. Reviews and essays by Woolf's contemporaries.

Marcus, Jane, ed. *Virginia Woolf: A Feminist Slant.* Lincoln and London: University of Nebraska Press, 1983. Includes a number of useful articles on Woolf's relationship to other women writers.

Marder, Herbert. *Feminism and Art: A Study of Virginia Woolf.* Chicago: University of Chicago Press, 1968. One of the earliest studies of Woolf as a feminist.

Matro, Thomas G. "Only Relations: Vision and Achievement in *To the Lighthouse.*" *PMLA* 99, no. 2 (March 1984): 212–24. Interesting alternative reading of Woolf's use of Roger Fry.

Meisel, Perry. *The Absent Father: Virginia Woolf and Walter Pater.* New Haven: Yale University Press, 1980. Interesting for its connecting of Woolf to her literary past.

Moore, Madeline. *The Short Season between Two Silences: The Mystical and the Political in the Novels of Virginia Woolf.* Boston: Allen & Unwin, 1984. Stresses the various aspects of Woolf's perception of women.

Naremore, James. *The World without a Self: Virginia Woolf and the Novel.* New Haven and London: Yale University Press, 1973. A useful study addressing important thematic and stylistic elements of Woolf's novels.

Richter, Harvena. *Virginia Woolf: The Inward Voyage.* Princeton: Princeton University Press, 1970. Good analysis of Woolf's techniques.

Rose, Phyllis. *Women of Letters: A Life of Virginia Woolf.* New York: Oxford University Press, 1978. A useful biography that relates Virginia Woolf's life to her writing, emphasizing the feminist perspective.

Rosenthal, Michael. *Virginia Woolf.* New York: Columbia University Press, 1979. Good general study of the novels, set in the context of Woolf's life.

Spilka, Mark. *Virginia Woolf's Quarrel with Grieving.* Lincoln and London: University of Nebraska Press, 1980. Focuses on Woolf's portrayal of death and grieving.

Vogler, Thomas A., ed. *Twentieth Century Interpretations of "To the Lighthouse": A Collection of Critical Essays.* Englewood Cliffs, N.J.: Prentice-Hall, 1970. A good collection showing diverse approaches to the novel.

Index

About the Author

Alice van Buren Kelley is currently undergraduate chairperson and associate professor of English at the University of Pennsylvania. She received her B.A. from Smith College and her Ph.D. from City University of New York and has published *The Novels of Virginia Woolf: Fact and Vision* (1971) as well as articles on Charles Dickens and Thomas Mann.